MW01118864

Kalamazoo and Southwest Michigan

GOLDEN MEMORIES

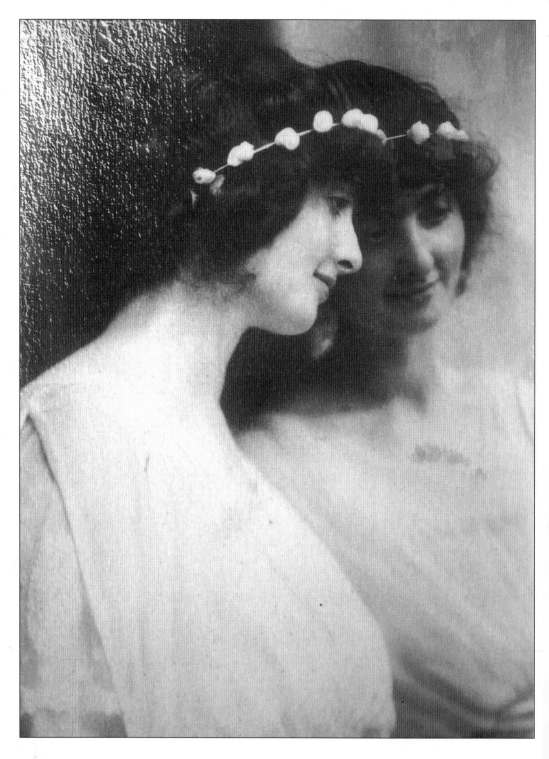

Unknown young woman prepares for her wedding. (Courtesy of the Augusta McKay Library Historical Collection.)

VOICES OF AMERICA

Kalamazoo and Southwest Michigan

GOLDEN MEMORIES

Lee Griffin

ARCADIA

Copyright © 2001 by Lee Griffin
ISBN 0-7385-1910-3

Published by Arcadia Publishing,
an imprint of Tempus Publishing, Inc.
3047 N. Lincoln Ave., Suite 410
Chicago, IL 60657

Printed in Great Britain.

Library of Congress Catalog Card Number: 2001092770

For all general information contact Arcadia Publishing at:
Telephone 843-853-2070
Fax 843-853-0044
E-Mail sales@arcadiapublishing.com

For customer service and orders:
Toll-Free 1-888-313-2665

Visit us on the internet at http://www.arcadiapublishing.com

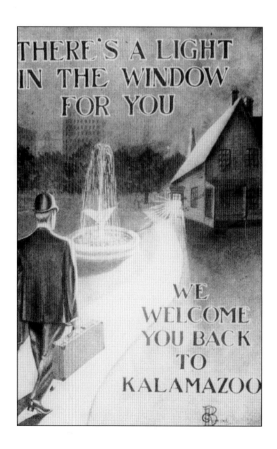

To Bob

For love, belief, and

encouragement

An old poster welcoming return visitors to Kalamazoo. (Courtesy of the Rick Shields Historical Collection.)



CONTENTS

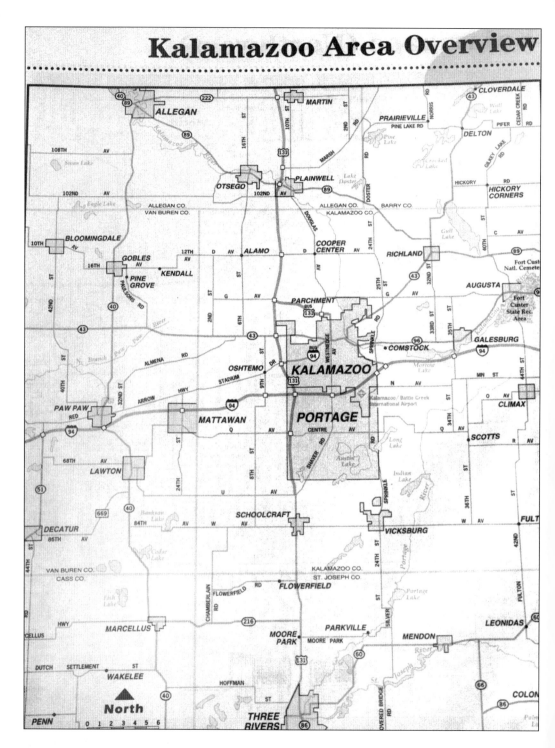

A map of Kalamazoo and outlying towns and villages. (Lee Griffin photo.)

ACKNOWLEDGMENTS

I wish to thank the Kalamazoo Arts Council for its individual artist grant which partially funded this project, my husband for keeping the faith, our children Joe and Joan, and Jon and Jill and their families for their support.

I am especially grateful to Mark Schauer, M.D., and Marti Quinn, R.N., for their generous help and unwavering interest.

Special thanks go to former colleagues Mari Leamy, Linda Mony, and other staff members of the McKay Library in Augusta for their willingness to do everything possible to make my writing life easier.

Among those who have contributed to this work in various ways are author Diane Charles VanFulpen, glass artist Martha Croasdale, and long-time regional newspaper editor, Dale Betwee.

Thanks and gratitude also to Brendan McKenna and other staff members of Arcadia whose interest and hard work made it all happen.

To all others who provided assistance, please accept my sincere thanks.

Most of all, I would like to honor the subjects of this book who willingly shared their memories and recollections of sometimes painful and deeply personal aspects of their lives with candor and openness.

L.D. Griffin 2001

INTRODUCTION

The subjects of this book were interviewed from 1999 through 2001. Therefore, the majority of individuals at this writing are one to two years older than their ages indicate. For example, Jesse McArthur who was 103 when I talked with her, is now 105. All persons in the book are living today, with the exception of Dale Shroyer who died in May, 2000.

All those who share their personal stories, values and beliefs, reside either in the city of Kalamazoo and Portage (located midway between Detroit and Chicago) or in small towns and villages within a 50-mile radius. Among these communities are Richland (including Gull Lake), Galesburg, Augusta, Hickory Corners, Lawton, Allegan and Marshall.

These ordinary, hard-working citizens are representative of men and women everywhere who are independent and maintain social contacts with friends and family. They also remain productive and retain a curiosity for current events and an interest in daily life.

However, personal narratives do not reveal everything there is to know about an individual, nor does reminiscence offer a definitive picture of history. Nevertheless, these golden voices deserve the right to be heard and respected.

Text in italics indicate an individual's own words. In some cases, sentence order has been changed for clarity and continuity.

Unknown girl. (Courtesy of the Augusta McKay Library Historical Collection.)

Dr. Wen Chao Chen

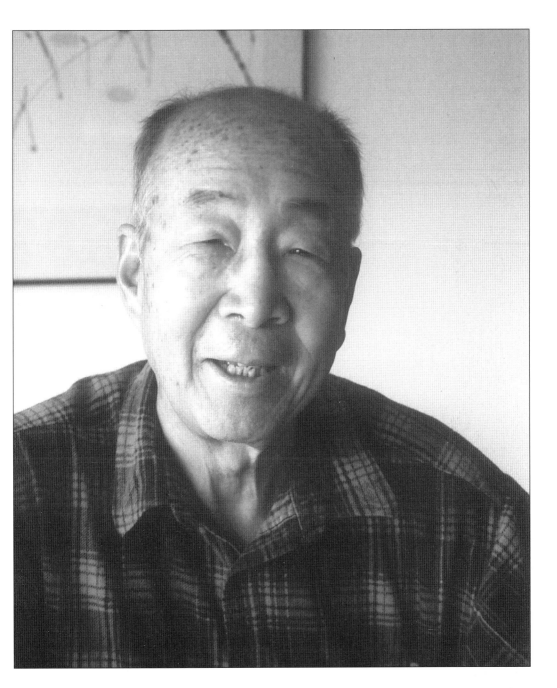

Retired Kalamazoo professor and administrator Dr. Wen Chao Chen, c. 1999. (Lee Griffin Photo.)

Several persons suggest I talk to Dr. Chen, a well-known resident of Kalamazoo. I know little about him except for what I read in the newspaper. I'm aware he has a connection to Kalamazoo College and that he is active in civic affairs.

I meet Dr. Chen on a spring day at a choice retirement village in Kalamazoo where he lives with his wife, an artist. We become acquainted in the facility's restaurant over lunch. He graciously points out I am his guest and insists on paying the bill.

Following lunch, I interview him in his apartment on the second floor. A broad expanse of windows overlooks a courtyard and flower gardens. Throughout the open living room and dining area, Chinese paintings, hand-crafted vases, bowls, and other oriental artwork are prevalent. Chen sits on a off-white patterned sofa and we begin to chat.

Chen, 80, has a Ph.D. degree in political science and two master degrees, one in public administration and another in library science. He also holds three honorary degrees; one from Western Michigan University, one each from Kalamazoo College, and Nazareth College.

"I was born in a small village located in north China called Chen Village, which belongs to my family. Two thirds of the residents or nearly 150 families are Chen descendants.

"The first school I attended as a very small boy was located in the hamlet, inside a Buddhist temple. At the entrance are two fierce figures. When you get in there you will see a representation of Hell. One statue holds a fork, ready to throw a wayward man into boiling oil. Then there is a bronze post with a fireplace at the bottom. There is a figure of a person embracing the post who will burn to a crisp. You see the suffering on his face."

Chen notes he is one of 12 students, all boys. Girls do not attend. School has been in session since September when there is no farm work to be done. It is December and very cold.

Chen walks through the courtyard and stops at the west side where a picture of Confucius is prominently displayed.

"I bow three times to the greatest of teachers and then I step up a few steps to the stage. On the right side is the teacher's room. On the left is where the students are."

Next, Chen bows in respect to the wise old man who sits on a large platform with his legs crossed. A small fireplace radiates heat, a luxury, Chen relates, that only the teacher receives.

"I obtain my daily assignment. It includes memorizing several Confucius sayings and three-character classics."

Next, he leaves the area, crosses the stage, and enters the student room, which is bone cold and quiet.

"Teacher never enters here unless he hears commotion. He finds the offender who holds out his hands. The teacher hits, using a wooden plank.

"By the middle of the morning when everything is memorized, we go back to the teacher's room, hand him the book with both hands, (a sign of respect) turn around, and begin reciting.

"If you forget or he didn't like what you said, teacher have this long bamboo pipe with a bronze bowl and hit you. Hot ash drop on your head occasionally. When you go home and father see the spot on your head, he say you must have misbehaved."

Later, Chen went to live with his older brother who lived in Taiyuan and worked at the post office.

"That's when I went to city school. The first year was terrible. I didn't know arithmetic. I didn't know anything except the traditional things I was taught to memorize.

"That's where I saw an electric bulb for the first time. It was just magical to see. Suddenly, it goes on all over the place."

When Chen was 11 years old, his brother sent him to a boarding school called The School for the Poor. For two Chinese dollars a month[1], he had room, board, and schooling, with the condition he work for a

Dr. Wen Chao Chen when he was director of the Kalamazoo Forum, c. *1986. (Courtesy of the* Kalamazoo Gazette.)

teacher or principal.

"By the time I was in what you call seventh and eighth grade, I was in boarding school. I had no problem academically. I took care of the principal's rabbits, bees, and pigeons. I was also responsible for waking up a teacher every morning. I started a fire in his room and heated water for him to wash his face.

"The dorm room was locked from 3 to 5 p.m., so you are forced to go outside to exercise."

Chen attended a junior high school, one his brother attended several years earlier. After he graduated from junior high, he says he had a falling out with his sister-in-law.

"It was probably my fault. She make me some clothing for graduation. The pants were too short in the legs, so I wrote her a letter saying thanks for nothing. My brother said, 'Well, if you are that big, then you can help yourself.'

"Anyway, I didn't want to go home again, because I didn't want to be a farm boy all my life. I scrounged around for a year until my brother cooled down. He said if I do this, this, and this, he would send me back to school. I told him fine. I did that.

"I was in high school, but by July 7, 1937, the Japanese had come to Peking, only 500 miles from where we lived. The governor of our province assured us that they would take care of the Japanese and we should go back to school. By November of that same year, the Japanese were in our village, so my family went south.

"If there was a highway or railroad, the Japanese took everything at will. The Chinese were no match, technologically, so they went back to the mountains where there were no roads. The Japanese were stuck."

For several years Chen floated, then took a national exam to go to college. He and a friend agreed that whoever passed the examination first would take the money both of them had earned and use it to attend college.

"My friend passed the first time and I didn't, so I gave him the money. He went out on a date with a young lady and came home empty handed. A pick pocket lifted all his money. He went to college anyway."

A year later, Chen also enrolled in college, but wasn't required to pay tuition. The government paid his room and board. He needed funds only for spending money.

"To earn money, I worked for a newspaper as a proof reader. Proof reading in Chinese newspapers starts at 10 in the evening and finishes up at 6 a.m. You proof read, then run the copies.

"I did that for awhile, but then it interfered with my classes, so I quit. Then I had no spending money."

After the Japanese attacked Pearl Harbor, the Chinese and Americans agreed to work together. Chen then joined the Chinese Army. He had completed three years of college.

"I was a military interpreter after the Burma Road campaign[2] in 1944. Then the United States Army began to select 100 people to come to the United States. I was one of them. I was picked because I was the chief interpreter of the Chinese Army which had three divisions.

"After the war was over in 1945, it became obvious we were no longer needed for military purposes, so we asked the United States Army to let us out. They told us we were in the Chinese Army, so ask them. That we did. They said we were attached to the American Army. We asked both armies and proceeded to apply to colleges. Of the 100 interpreters, half applied to colleges. The rest of them went home."

Chen didn't have the funds to finance his education so he lived with the chaplain and his wife at Grinnell College in Iowa. In exchange for room and board, he cleaned house, washed dishes, and baby-sat. He remained there a year, long enough to finish his degree in political science. He then went to graduate school at St. Louis University in Missouri where he lived with a minister and his family, performing similar household chores as he had at Grinnell. In addition,

Chen received $2 a week for car fare.

During this period, the political situation in China worsened, so Chen decided to stay in the United States and begin pursuing a Ph.D. degree.

"I met my future wife at St. Louis University. Her family was in much better circumstance than mine. I say this frequently. If we were both in China, her family would not let me darken their door. They had several shoe factories and more than 300 employees. I didn't have any money. Anyway, I was glad she was there.

"She is Chinese, too, born and raised in Peking. She went to Catholic University in China. There was a Chinese bishop who was very articulate in English. He came to the U.S. and talked many Catholic schools into accepting students from the Catholic University in China. That's how she came."

The year 1950 was a significant one for Chen. He moved to Kalamazoo, Michigan, to teach political science half time at Kalamazoo College, and finish up Ph.D. degree.

"I lived in the college president's house on the third floor. I persuaded Lilia to marry me in December of 1950, and we moved into prefabricated housing near campus. My salary that year was $1500, and the rent was $28 a month, including the furnishings.

"I am so grateful she married me, I established a scholarship in pottery at the Kalamazoo Institute of Arts[3] in her name."

In addition to teaching political science, Chen wore a number of hats during his 36 years at the private institution.

"I was professor, librarian, dean of special services which covers a lot, acting president, and vice-president. I became the acting librarian while still teaching political science. I was on the faculty library committee at the time when both the librarian and the college president were planning to leave. It was decided not to replace the librarian until a new president was hired. I was the junior member of the committee and since nobody wanted to do the job, they said, 'You are it.'

"Those who didn't like what I did would say I was the president's henchman. I didn't have to fire people, but sometimes I did and said things that the president didn't want to do or say, but needed to be done.

"In fact, a couple of days after I became vice-president, the president of the college had a heart attack. So for the next six months, I was taking pot shots in his chair because this was 1970 and people were asking for a change. One of the things they demanded most was to have mixed dorms. My personal feeling was, so what? The president was very strongly against it. I felt since I was sitting in his chair, I was obligated to follow his policy.

"Some of my colleagues wanted to make a feat complete—make a change so when the president came back, it is already done. I told them I couldn't look in the president's eye if I did that. People call me a few names."

For a few persons at the college, Chen's position of power didn't set well. Nevertheless, Chen says he understands and bears no grudges. There were other unpleasant incidents as well.

"Next to the county building there is a bench. Back in the 1950s, the drunks always sat there. Frequently, when I would walk by, one of them say, 'You damn Chinaman, why don't you go back where you came from?' I heard that, but what can I do? I pretend I didn't hear."

He cites another incident in which his oldest son was picked on in church by other children. Chen spoke of it to the person in charge of Christian education. She told him there was nothing she could do. She didn't want to hurt other people's feelings.

"Later, when that woman got sick, I thought of paying a call on her as a Christian, but as the father of a son who was discriminated against, I thought, hell no."

On another occasion, youngsters teased Chen's son in nursery school. This time the teacher pulled the boy on her lap and explained to the kids that not everyone looked alike.

"The teacher happened to be the wife of a

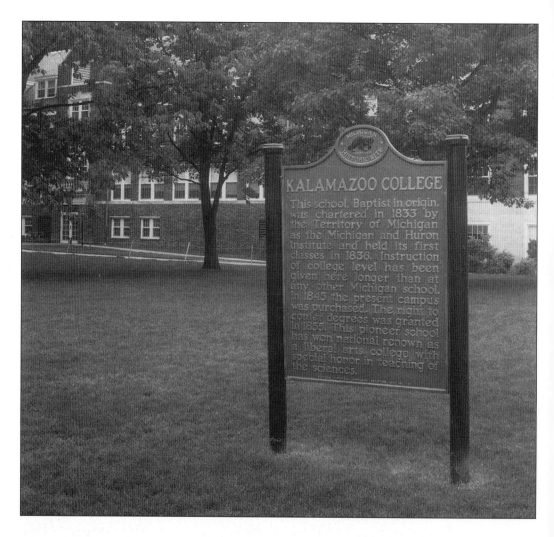

Kalamazoo College as it appears today was chartered in 1833. Baptist in origin, the liberal arts college is renown for the teaching of the sciences. (Lee Griffin photo.)

friend. Now, after all these years, I feel grateful. Every time we see her, the first thing we do is take her out to lunch."

At Kalamazoo College Chen worked for four of its presidents. He also served as manager for the L. Lee Stryker Management Center, which offers classes in management, consulting, and the training of supervisors, among others.

Chen was also involved with the Forum of Kalamazoo County, a group charged with determining how a number of political jurisdictions could cooperate for the

common good, and he also served as moderator for an organization called the Core Council of Governments. It was comprised of seven political entities working towards combining services in the most economical manner.

Chen's father and his oldest brother had the most influence on his life, Chen relates.

"In my youth, my father had the most influence because he was the disciplinarian. The traditional Chinese system is: father is stern, mother is kind.

"For example, when we had dinner and

my father was present, you did not speak unless you were spoken to. I am the youngest of five siblings. If my father put his chop sticks down, I had better stand up and go get more food for him, or he would sigh and say, 'The world sure has gone bad.'

"My oldest brother was another definite influence on the course of my life. He made it possible for me to receive an education."

Chen talks about the two hardest decisions he ever had to make. One was whether or not to change jobs, and the other was changing his citizenship from Chinese to American.

"I had to decide if I wanted to give up my security here in Kalamazoo and go somewhere else or stay. We have no family here. I always worried about what would happen if I am without a job. My family would be stuck.

"The change of citizenship is like being adopted by your uncle when your parents are still alive. Anytime the two countries have a quarrel, you are squarely in the middle. We are in the middle right now as the Chinese are accused of stealing defensive secrets from the U.S.

"My wife wanted us to become citizens because if I passed away, she would have no place to go. Communist China confiscated all of her family's assets."

Chen believes that we are victims of our own success in technology, and it is a problem we are facing today.

"Technology moves too fast for human beings and it is causing us to change relationships. Women, for example, don't have that much housework to do anymore because of technology. But some people, particularly males, still think women should stay home. If they stay home many are going to be unhappy. They see all these things, good and bad, and they want to try their hands. Okay, but socially we are not structured.

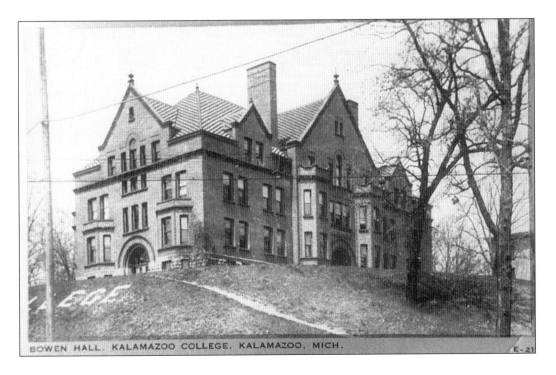

An early photograph of Bown Hall, Kalamazoo College. (Courtesy of the Rick Shields Historical Collection.)

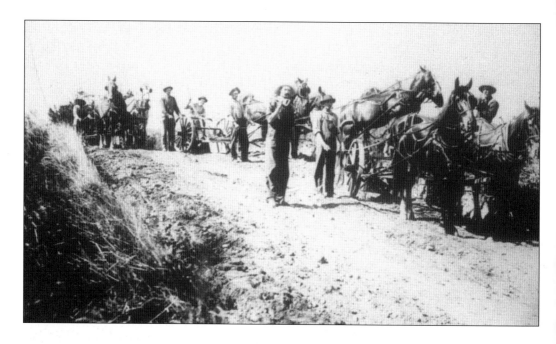

Horsepower helped build many roads in Kalamazoo County during the 20th century. (Courtesy of the Rick Shields Historical Collection.)

"Another thing we are in trouble with is our idea of personal freedom. I am supposed to be free to do anything I want. Well, that's fine, but you have to show responsibility. Modern technology created desires, but didn't provide the money unless you worked for it. A lot of people, said, 'You owe me,' so the schools owe the parents to educate their children. Therefore, the parents don't do much."

Chen's parents never got the chance to visit their son and his family in the United States.

"When they were still living, the U.S. and China didn't speak. By the time that changed, they were gone. I would have loved to have them visit. In the place where I was born, the country magistrate was the big shot. People who went to see him had to have hat in hand, stand there, and say, 'Yes, sir', or 'no, sir.'

"My mother used to say to me, 'If a time comes when you can go see the magistrate and he would offer you a chair, I would die happy.'

"In the Core Council of Governments,

there were mayors, presidents of companies, and all kinds of people. They were all looking to me for leadership and I was telling them what to do. I know my mother would have been tickled pink."

END NOTES

1. *At that time the exchange rate was three Chinese Yuan to one U.S. dollar.*

2. *The Burma Campaign was the longest fought by the British during the World War II. It began in 1941, and ended in 1945 with the defeat of the occupying Japanese army. The battle was fought with the Allies' intention to keep open an overland supply route to the Chinese.*

3. *To celebrate his 50th wedding anniversary, Chen also arranged to fund an annual art scholarship for students at Kalamazoo College in honor of his wife, Lilia, who has made pottery for the past 30 years.*

RICHARD HOOGENBOOM

Richard Hoogenboom, who served many years as treasurer of the Augusta McKay Library board, is shown here conferring with Library Director Linda Mony, c. 1999. (Lee Griffin photo.)

Richard Hoogenboom was treasurer of the McKay Library board when I first met him in my job as staff librarian. The facility is situated in the village of Augusta, located midway between the cities of Battle Creek and Kalamazoo in Southwest Michigan.

Richard remained a board member for more than 10 years until a mild stroke and other health problems prompted him to relinquish his duties at age 83.

At the board meetings it became immediately clear that Richard was deeply religious. Never did he swear, tell risque jokes, nor speak ill of another person during his tenure.

These days, Richard, despite his own health problems, is the primary care giver for Jen, his wife of 61 years. Jen, who has heart problems and has suffered several strokes, is confined to a wheelchair. Richard relies on paid help for assistance in meeting his wife's needs. The couple have a son and daughter.

I interviewed Richard in his Gull Lake residence, situated 15 miles from Kalamazoo. Near the doorway is a wooden sign depicting two black birds. Below are the words: "Two old crows live here."

In the blue carpeted living room is a fireplace, spinet piano, and red velvet chairs. The large picture window offers a panoramic view of aquamarine water, houses, docks, and bobbing boats. Jen sits silently nearby as Richard and I talk.

Richard was born in Goshen, Indiana, in 1916. His father, who was a victim of sugar diabetes, died at age 29, when Richard was five years old. At the time, insulin was not available for use in the treatment of this disease.

"In so many ways, life is different than when I was a child. Nobody had to worry about being mugged and activities were more family oriented. People were not on the go as they are now.

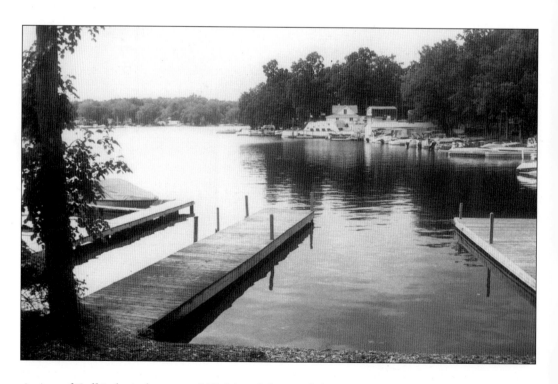

A view of Gull Lake today, one of Michigan's largest lakes comprising more than 2,000 acres. (Lee Griffin photo.)

"When I was a kid, my folks rented a lake cottage on Gun Lake for a weekend. That was the extent of our summer vacation. We didn't have much money and this was all the family could afford.

"Transportation was also very different. In the Goshen area there were a lot of Amish people and a lot of horses. In fact, my father never owned a car. He had a horse and wagon and didn't even have a buggy. He had what they called a spring wagon with an open box that was used to carry produce in. My father would travel from Goshen to Elkhart, a distance of 10 miles, twice a week with produce. He would start out before daylight and come back home after dark. Sometimes I went with him. I would sleep on the sack of hay my father took along to feed the horse. I couldn't have been more than three or four years old.

"There was a place in Elkhart where the horses and people congregated. We would go there and eat our lunch out in an open area with everyone else. On Saturday nights everyone went to town. We lived about a mile outside of town so we walked. Back then, there were sidewalks that went all the way into town from our home. Like everyone else, we'd walk around town and buy groceries then tote them home. That was our entertainment."

A year or two after his father's death, Richard's mother met a man from Kalamazoo who operated a small grocery store there. They married and the family moved to Kalamazoo. Richard attended a one-room school, comprising eight grades. He was in the first grade.

"It's funny, the things you remember. For our morning break we would have half-pint bottles of milk. The teacher had a 16-penny spike he kept in his pocket. He would punch this nail through the paper milk caps so all of us could stick our straws through. I suppose it wasn't very sanitary, but it worked.

"None of the subjects in school were my favorite. I was a poor student, very poor. I did fine up to the ninth grade. I guess I couldn't concentrate, but I didn't dislike

Richard Hoogenboom served his country in 1941. (Courtesy of the Hoogenboom family.)

school, particularly. I didn't have trouble reading, either. I was a slow reader, however, and I read every single word. No, high school at Kalamazoo Central was not one of my better times."

When he looks back on those days, two teachers come to mind.

"One was Eva Payne Cairns. She taught world history. She was an excellent teacher, an old maid, really tough. She'd read from a book and pass it around so we could look at the pictures. It was written in Latin and she could read it well. She was a real character. She'd say, 'Go to the head of the class' if you did well and 'Go to the foot of the class' if you did poorly.

"The kids made fun of her because she carried a little bag and would walk along waddling like a duck. The school yearbook had a showed a rear-view picture of her walking down the hall. That made her so mad, but she was an excellent teacher and I'll never forget her. I didn't do well in her

GULL LAKE.

One of the most Charming Resorts for pleasure parties in in this section. EASY OF ACCESS.

Good Accommodations

FOR EVERYBODY, AND

PLENTY OF STABLE ROOM FOR HORSES.

GULL LAKE is a most beautiful sheet of water, SIX MILES IN LENGTH, clear as a crystal, with a fine gravelly beach, heavily wooded shores, and surrounded with picturesque and romantic scenery. Its waters abound in Bass, Pickerel and Perch, and it has long been a Popular Resort of Lovers of Fishing Sports. The Lake is 12 miles from Kalamazoo and Battle Creek, 6 miles from Galesburg, and 4 from Augusta,—from either of which places it can be reached by delightful drives, or from all towns on the M. C. R. R. by rail to Augusta, where arrangements have been made with W. R. GIDDINGS, to convey passengers to the Lake *for 25 cents each*, or in parties of eight or more, *at 25 cents for the round trip.* All those going by rail in parties of 10 or more, are entitled to Excursion Rates.

THE STEAMER CRYSTAL.

This Boat was built this season, is 61 feet long by 13 foot beam, and will carry 200 persons with perfect safety. It is entirely inclosed in case of rain and is managed by men of experience. The Steamer will be fired up and run a trip for 25 full fares or over.

Sabbath School Picnics will be carried at $10.00 for 100 persons or more.

Boat will run Sundays as follows: Leave St. Louis at 1, 3 and 5 o'clock, and returning leave head of lake at 2, 4 and 6 o'clock. Also one regular trip each Wednesday afternoon at 4 o'clock. Fare for round trip, 25 cents; Children, 15c.

CAMP ST. LOUIS,

The Headquarters of the Steamer, is on the east side of the arm of the lake and in a beautiful Grove containing 12 acres of ground, and buildings to accommodate 1,000 persons as shelter; also tables in both grove and building.

For information regarding Grounds address H. G. Wilson, and Mich.

An early handbill extolling the virtues of Gull Lake as an ideal resort. (Courtesy of the Augusta McKay Library Historical Collection.)

class, though. Apparently, I just wasn't willing to work."

Another high school teacher comes to mind. Richard fails to remember her name or the subject she taught but he'll always remember the circumstances.

"We were poor. All I had were shirts with long sleeves. On this particular day, the classroom was very hot so I rolled up my sleeves. She shouted in front of the whole class, 'You roll down those sleeves!' Then she kicked me out of class. I was embarrassed to tears. There was no call for it. It accomplished nothing except to humiliate me."

One of the first jobs Richard held following high school graduation was driving a dry cleaning truck. He earned $8 a week plus a percentage of any new business he could round up.

"When I made a delivery, I was supposed to visit each house on either side and ask the owner if he had any dry cleaning. I never sought extra business because I was too shy. Also, I got caught speeding so often most my salary was spent paying for tickets. I didn't last long at that job—maybe two or three months."

Richard also worked for his step-father who taught him the paper hanging and painting trade. Later the two made a pact to go their separate ways in the business. Richard continued the trade until he landed a position with the post office.

"I grew up during the Depression, when jobs were hard to come by, so a steady job was sought after. My mother always asked why I didn't get a job at the post office. She even asked the postal carrier who came into our grocery store, which was in the North end of Kalamazoo, to let us know when postal examinations were to be given."

Eventually, Richard took the exam, along with 500 other persons. Of that group, Richard was one of 18 who were hired. He was 19 years old.

"I was what was called a substitute (walking city) carrier. As far as wages were concerned, back then there were only four grades of city carrier. Clerks were the same.

At age 19, Richard Hoogenboom worked as a substitute mail carrier in Kalamazoo and retired from the rural route in Augusta after serving with the U.S. Post Office for 37 years. (Courtesy of the Hoogenboom family.)

There were four pay grades for city carriers and clerks. The first level paid $1700 a year, and if you stayed on you could advance $100 each year up to $2000.

"My first wage paid 65¢ an hour. If I worked past 6 p.m. I received 71¢. It was considered very good pay back then, because men with families were working with the WPA for $16 a week. They supported families on that.

"Sometimes I'd work 100 hours in a two week period, bringing home $65 to $70. Because I was a federal employee, no social security was taken out of my paychecks. I don't remember paying income tax, either. If there were such a tax, I guess I wasn't making enough money to pay, anyway."

In 1946, Richard became a rural carrier in Kalamazoo. Nearly a decade later, he transferred to Augusta where he worked the rural route until he retired in from federal

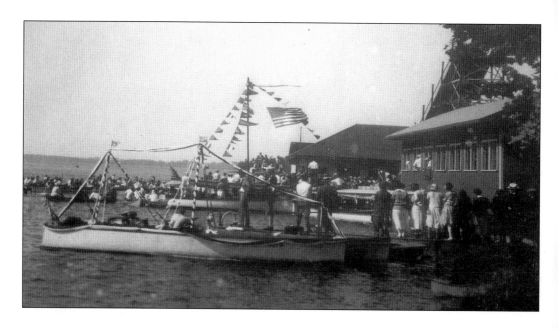

Hawk's Landing at the south shore of Gull Lake was a favorite gathering spot for boating enthusiasts in the 1900s. (Courtesy of the Richland Community Library's Local History Collection.)

post office in 1974.

"*I met Jen at Central High School and have known her since I was 15 years old. I don't know whether we had any classes together or not, but we were in the same home room. It was Gertrude Miller's home room. She was a strict disciplinarian with big, black eyes.*

"*Her home room held nearly 300 kids, yet she could pick you out in the back. Just one glare from her made anyone shrivel. You had respect for teachers.*

"*I was 15 and Jen was 17. I took her home one night and her mother asked, 'How old is that boy?' Jen said 17 because that's what I had told her. Her mother was a teacher and used to sizing up kids. I remember she said, 'He doesn't look very old.'*

"*I thought Jen was pretty. Back then, a pretty face was the attraction. We got married at her farm home in Cloverdale, right in the living room. The reception was right there. Cake and ice cream, that's all anyone used to have. It was a pretty simple affair.*"

Richard reflects on the period of his marriage 61 years ago and compares it to the present age.

"*When we were married people stayed married. Divorce was looked down on. We had rough times like everyone else does, but it never got so rough that we didn't stick together. I think when you made a commitment then, it meant more that it seems to today.*

"*Jen had a very strict moral code. I was young and didn't have very many responsibilities and I was willing to run around like anyone else. She wouldn't put up with it. That was the bottom line—and I knew it. It was the best thing that happened to me when I married Jen. It really was.*"

Eventually, Richard was drafted into the service. The couple had one child and another on the way. Nevertheless, Richard was shipped to Japan to work in the post office located between Tokyo and Yokohama. His outfit was told they would be aboard the first ship that sailed directly from the United States to Japan after the atomic bomb was dropped.

"*We worked in a replacement center, a*

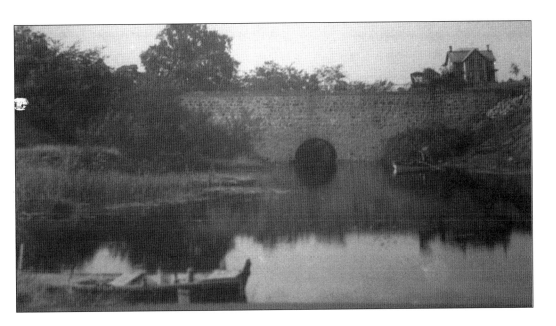

In the middle 1800s, motorists traveled this old stone bridge spanning Lover's Lane at Yorkville, the outlet to Gull Lake. It was declared unsafe in 1926 and rebuilt with modern materials. (Courtesy of the Augusta McKay Library Historical Collection.)

nice facility comparable to West Point. Our outfit (APO 703) consisting of 30 guys lived right up over the post office. We did a great deal of business with soldiers who were sending money orders home and such. All our business was done in Japanese yen. At the time, 15 yen equaled $1.

"Twice a week we filled a hamper with Japanese money and took it to the bank in Yokohama or Tokyo. Every week the postal officer, a first lieutenant, would choose a fellow to drive him to the bank. Driving was done on the left side over very narrow roads through many little villages. It was quite an experience."

Although Richard treasures those memories of the past, his thoughts often focus on the present and the future.

"Nursing homes are great for people who have to go there, but I hope neither one of us has to go there. Jen was in a nursing home for a couple of weeks and received good care, but I was there every day to make sure she did.

"Before nursing homes existed, the elderly moved in with their relatives. Every family had an old maid aunt or a mother or father living with them. I'm sure it wasn't always the easiest situation, but they took care of their own. Now we've gotten away from it. These days, both husband and wife worked, so there was no one at home to care for these older people. It is a problem.

"I hope I never have to live in one. I've made up my mind that within my power, Jen will never have to be placed in one, either. I'll hire extra help in the home and end our days right here.

"The most stressful periods in my life have been when Jen has been sick. We were up north camping, almost as far up as Copper Harbor. We were down at the beach, picking up agates and other pretty stones. She had trouble walking back to our trailer. She was breathing hard and had to stop and rest every few feet."

The couple's daughter-in-law, who lived in the area, scheduled an appointment with a physician who said he could put Richard's spouse in the hospital for additional tests. If

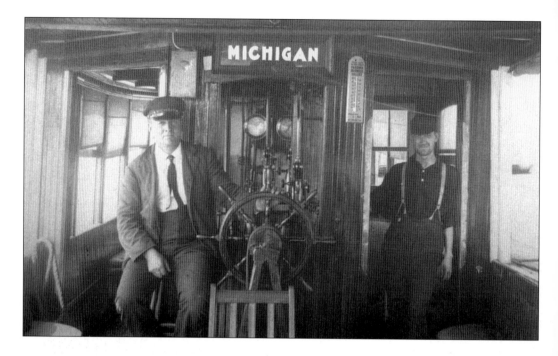

The excursion boat Michigan with Captain Martin Brown at the wheel cruised Gull Lake waters between 1896 and 1898. (Courtesy of the Augusta McKay Library Historical Collection.)

her condition proved serious, he gave Richard two choices: she could be transported 100 miles south to a large hospital in Marquette, or he could give her nitroglycerin tablets until the two arrived back home.

"We chose to come home. We started at noon and arrived home at 10 p.m., a total of 600 miles. We left our trailer on the shores of Lake Superior until our family brought it back to us, later.

"Jen had heart by-pass surgery a few days later. Within four years she had a stroke. She has since had several strokes, but one affected her left side and crippled her. But, then, the whole world has problems. Why should Jen and I be different?

"We've been going through some kind of rough times. If it were not for our faith we could become very discouraged. Jen and I were both saved and we consider ourselves Christians. I don't see how people who don't know the Lord or have a Christian attitude can get along. This is what keeps Jen and me going, right now.

"I believe our lives are ordered and we are here for a purpose. I really do. We can't see it now, but years down the road as you look back, you understand the purpose. It's amazing, just amazing, when you finally learn how these things work out.

"I would like to be remembered as a good father and a faithful family member and as a good person who had a good effect on the rest of the family. This would make me very happy."

END NOTES

1. *The Works Progress Administration (WPA) refers to the many agencies established by the Federal Government in the 1930s during President Franklin D. Roosevelt's administration. Its purpose was to provide jobs for the unemployed who were able to work but couldn't find jobs.*

The WPA eventually employed nearly one third of the nation's 10 million unemployed.

Jess Adams, c. 1999. (Lee Griffin photo.)

Ninety-four-year-old Jess Adams and his wife, Kathryn, who is of the same age, live in a sprawling retirement complex in Kalamazoo. Their small apartment is comfortable and tastefully furnished. The couple takes pride in the showy flowers they tend in large pots on their patio.

Both Jess and Kathryn married previously, and each lost his spouse through death. The two were well acquainted. Kathryn's first husband, a grocer, operated his business in the same town as did Jess, also a grocery shop owner. They now have been married to each other for 43 years.

Jess was born in Sherwood, Michigan, located 35 miles from Battle Creek. He grew up on an eight-acre farm with his brother and sister, both of whom were older.

Jess: *"My mother died when I was five-*

A high school photo of Jess Adams, c. 1921. (Courtesy of the Adams family.)

years old. My father was a widower for three years. When he married, it was to a younger woman. He was 44 and she was 23. Father had a little business going besides farming. He had a cider mill in which he made apple cider every fall. He also made sorghum molasses and had the first mint still in this part of the state. When people first started raising mint it was grown on upland. After my Dad started selling mint roots mint was being grown on muck land. Our mint distillery had six tubs for the operation. I remember he sold his boiler to one of the other mint distillers. Just how he got into the business, I don't know. I was so young."

Kathryn: *"I was born and raised on a farm in St. Joseph County, near Colon. I had a half-brother and half-sister. It was a regular farm with horses, cows, pigs and chickens. My grandfather received the farm from the government through homesteading.[1] We had 120 acres.*

I attended school through the 12th grade and graduated from Colon High School."

When Jess was 14 and attending high school in Colon, he began working for a prominent local physician.

Jess: *"The doctor was looking for a boy to live with him and take care of his place. I worked for my room and board. It was one of the greatest things that happened to me because we didn't have much at home.*

"When I went to live at the doctor's house, I didn't know what napkins was, hardly. At his table, there were silver rings for the napkins. There were little butter cups and little plates for each person and each person was served.

"I also had to take care of his two cars, both Model T Fords. This was in 1919. I had to pump up the tires every morning, 70 pounds. Even in town he had chickens, so I took care of them. He also had lots of gardens and I had to spade them.

"The doctor owned almost a whole block. His house had 26 room, counting the hallways and the third story. It was a nice place and I took care of it well.

"While I lived there, I got acquainted with

the girls around town. One girl's father owned a grocery store and he wanted help in the afternoon and evening on Saturdays. Of course, I had to ask the doctor if I could. He said, "You're doing your work here pretty well, I don't see why you can't.

"Well, I worked for him at the store almost all through high school. I did everything. The owner bought milk and cream and I tested the cream for its butterfat content. I waited on customers, too.

"In those days, everything was open (in bulk) and we had to package it. We bought sugar in 100 pound bags or barrels. We put sugar up and sold it in 25 or 50 cent packages. We did potatoes and lard in the same way. It was a wonderful education for me. Then, the store had to be kept clean. The wooden floors had to be oiled to keep the dust down."

Kathryn: "I went to a one-room school in the lower grades. People who had children kept moving out of the neighborhood. Finally there were two of us in the school, a boy and me. We were in the same grade. When one of us didn't have a book we would sit together and study.

"It was nothing like we have today. We had to go up in front and sit on a bench to recite. The school superintendent even let me take my dog to school. He was a big Collie. I was only eight years old and I had two miles to walk to school."

"They were afraid for my safety because there were so many bums on the road at that time. The dog had to carry his own lunch. At noon, I'd spread a newspaper down, dump his dinner on there and he'd eat with the rest of us.

"I had to come right home from school, change my clothes and go get the cows. I had my good old dog with me and he would go and round them up. As soon as we got home, I had to hunt the eggs. Next, I had to go inside the house and set the table for my mom. By that time, she would have supper ready. Then she would go and help Dad milk the cows while I cleared the table and put things away."

Twelve-year old Jess Adams with his brother, Harley, 13 on the left, c. 1916. (Courtesy of the Adams family.)

Jess married shortly after he graduated from high school (his first wife) and remained married for 53 years. He was employed for a couple of years in Battle Creek then came back to work in the same grocery store as he had in high school.

Meanwhile, Kathryn met a man from Ohio. After three years of courting, the two married. She was wed to him for 47 years. Her husband and his parents purchased a grocery store in Colon, only a few blocks from Jess' newly purchased grocery and meat market business.

Jess: "I knew Kathryn, oh, yes. We went to high school together, but we never dated. I knew her husband and she knew my wife."

Kathryn: "He was too busy with the girls to date me and I was too busy with the boys. We didn't have time."

Kathryn Adams, c. 1999. (Lee Griffin photo.)

Jess: "When I bought the grocery and meat market store it cost $3,345. I didn't have any money but friends and relatives gave me loans. I was 22 or 23-years-old—just a kid. People said I'd never make it. I didn't know how to butcher, but a man who worked for the former owner said he'd stay on. After I was in business a few months, I asked my brother to join us and take on one of those thousand dollars loans. He did.

"We bought our cattle right from the farmer. We'd go out in the country with a pickup truck, shoot the steer, butcher in the field, bring it back in and cut it all up. We did the same with hogs. We dressed them, rendered lard and made sausage. My brother did the butcher part, you see, and I did the grocery store.

"I drove the grocery wagon. I'd start out at 7 a.m. We had a sign that read "Adams" and we'd give it to our customers. There were very few telephones in those days. When I saw the sign in a customer's window, I would go inside the house and take the order. Then I'd go down one side of town, come back to leave those orders at the store, then go down the other side of town and do the same thing. We had service right to the door. Kathryn's store did the same thing for a while.

"When you work as close with people as we did, you get to know them well. If someone is sick or getting married or having troubles, you know it.

"I took care of elderly ladies. I cashed their checks, delivered mail and did other chores. I loved them. That's why I was pallbearer at more funerals than anyone in town."

In 1944 Jess sold his store and bought a farm. He started with 137 acres and wound up with 580.

Jess: "I was just a young chap and didn't know anything. I began to use fertilizer. The other farmers started using it but burned their crops. They learned. I had a nice farm, but to make ends meet, I had to rent more fields. You have to be a millionaire to start farming nowadays."

Jess remembers the first car he ever saw. In addition, both he and Kathryn remember the make of vehicle each of their parents purchased.

Jess: "That was something. Of course we didn't have any cars in our neighborhood at all. A fellow in the little town of Athens had a car and it was a big thing. He come down the road one day, and we wanted to see it better so we threw stones in ruts. That way the driver would have to get out. During those days, some of the cars were not self-stoppers. Some of them cranked on the side instead of in the front.

"My folks didn't buy a car until 1916 and it was a Maxwell. Nobody was rich. We traded a horse in to buy it.

"Course there was no roads paved and there was no gravel roads in them days either. In the wintertime, the road had ruts and then they would freeze. My Dad took the car to a sale one winter, and he got in one of those ruts and it took the rubber clean off the side of the tire."

Kathryn: "My Dad's first car was a Ford roadster, and that's the one I learned to drive on. When I was 14 I went to Centerville to get my driver's license. I got it for $2."

The couple also recalls the first time they saw an airplane.

Jess: "They started out in Union City, making a little flight. It was a machine like the Wright Brothers had. This was around 1912. My brother and I drove a horse and buggy over to see it."

Kathryn: "I saw the first plane when I was out on our lawn. I heard something coming so I looked up. Here came this biplane. I had my big dog with me and he looked up and saw it, too. He thought it was a crow so he ran across the field trying to catch it."

The couple discusses what they believe have been important inventions during their lifetime. Kathryn offers her opinions while Jess becomes sidetracked.

Kathryn: "I don't know how important they are, but rockets are doing so much for the generations, I think. And, of course,

Kathryn (Katy) Blausey Adams at age three, c. *1908. (Courtesy of the Adams family.)*

electricity was another wonderful thing.

"First, we had oil lamps, then lanterns. You had to light the oil lamps and wash the chimneys. With lanterns, you had to trim the wicks."

Jess: "We think we are quite modern. We gotta have two or three bathrooms. Well, we aren't so far ahead, after all. When we lived on the farm we had three bathrooms, all right. We had a three-hole outhouse."

Both of them are eager to share their favorite family stories. Jess tells his first:

"My grandfather, he prophesied. This was when he was a young man living in Michigan. He would come to town and stand on a rock and talk about the future. He said there would be machines with horse-less carriages. People thought it was hog wash. They gave him the name Crazy Adams. When I was going to school in 1919, there was an older neighbor who said he knew my grandfather. He told me Grandfather was a man way ahead of his time, that Grandfather knew what he was talking about."

Kathryn: "One day my grandpa went to Grand Rapids with a group of men who were taking grain there by horse-drawn wagons. When his wagon came back it was empty. It turned out that while he was in Grand Rapids he enlisted in the 11th Michigan Infantry during the Civil War. When he was away for quite a while, Grandma received a letter from him with a big splotch of blood on the paper.

"He had been in Chattanooga for six months but was unaccounted for. Grandma was told he was dead. One day she went to the door, though, and there stood Grandpa. She said he looked like a scarecrow, he was so thin. As it turned out, he had been sitting on a stump, writing to her when he got shot

The entire student body of the one-room Grabber School west of Colon includes, from left, Bertha Persailes, Lucy Harriger, nine-year-old Kathryn Blausey Adams, and Vincent Meyers. Dogs also attended the school. They are from left, Jack, Carlo, and Dewey, Kathryn's Collie, c. 1914. (Courtesy of the Adams family.)

By 1915, the Grabber School population had dropped to two pupils, George Krum and 10-year old Kathryn Blausey Adams. (Courtesy of the Adams family.)

in the head. He had been in the hospital at Chattanooga all that time."

The couple asserts that they have little difficulty being 94.

Jess: "*No, it's not hard at all. The older you are, the more courtesies you get. Land sakes, people will see me with my cane and want to help. I don't want to be helped. I want to be honest with people.*"

Kathryn: "*You want to be honest but not critical.*"

Jess. "*I wish I had words like some folks have.*"

Kathryn: "*The only difficulty I can think of is getting back and forth to doctors sometimes.*"

Jess: "*Oh, yeah. I drive. Listen. She does the drivin' and I do the steerin'. Now don't misunderstand me. She tells me how to get there and that's a great help.*"

Kathryn: "*We drive together. We don't drive evenings.*"

Jess: "*It doesn't frighten me to drive on the interstate. I like to drive there. Oh, yeah.*"

Jess tells of attending revival meetings at the Methodist Church in Colon when he was a lad and notes he was saved. Both he and his wife review their church affiliations and faith.

Jess: "*When I received the Lord, that didn't make me a good boy over my lifetime, but it has helped me all through my life.*

"*I've been a member of the Colon Baptist Church for 60 odd years. I still am. I was superintendent of the Sunday school for almost 25 years. Kathryn is a Methodist. I want her to go to the Methodist Church in Galesburg, but the stairs are too high.*"

Kathryn: "*I enjoy going out there but there aren't nearly as many people I know now that I once did. We can't hear the preacher. She doesn't talk loud. She has a microphone but she doesn't use it.*"

Jess: "*We both believe in the Lord Jesus Christ and if our time comes today, we're ready. And it's going to come. Now listen. I believe the Lord has a purpose for every person.*"

Kathryn: "*I think it's helping people. I do believe we are supposed to help people.*"

POSTSCRIPT

One year later, Jess says he quit driving. "I'm 95. I can't hear good or see good, so I shouldn't drive."

END NOTES

1. *Homesteading was the common term for the passage of the Homestead Act by Congress in 1862. The act allowed anyone to file for a quarter-section of free land (160 acres). The land became the individual's if at the end of five years he had built a house on it, dug a well, plowed 10 acres, fenced off a specified amount and actually lived there.*

MARGARET (MIG) MCKENZIE

Margaret (Mig McKenzie) loves to travel and to host parties, c. 1999. (Lee Griffin photo)

Mig McKenzie, at the age of 92, is known to her friends and acquaintances as the "party girl," a moniker she acquired during her teaching days in Detroit when she threw parties for every holiday and occasion imaginable. Nowadays, she hosts nearly a dozen parties a year.

She lives on Gull Lake near Richland, in a two-story white house with turquoise-colored trim. It is a prestigious area where parcels with lake-frontage sell for $2,500 per square feet. Mig acquired the real estate through her parents. Originally, her father purchased the cottage for $300 in 1920. Taxes that first year were $7. Mig took possession of the property in 1970 and spent her summers there until she and her sister both retired from teaching. The two sisters lived together until Janet died in 1992. Later, Mig remodeled the structure by tearing down several porches and adding two floors. The home now consists of four bedrooms.

Mig is referred as a likely candidate to interview by a number of her friends and acquaintances who were struck with her tremendous energy, sense of humor, and zest for life.

On a sunny, spring day, Mig and I talk in her living room, a large open area that overlooks the lake. Two card tables are set up to accommodate drop-in guests. A spinet piano separates the living and dining areas. Many of Mig's oil paintings adorn the walls and her wooden sculptures are placed throughout the house.

The day I interview Mig, she just returned from a cruise in the Caribbean, with visits to Barbados, Aruba, and Margarita Island.

"My grandmother and grandfather lived on Douglas Avenue in Kalamazoo on 120 acres. They gave Mother and Dad one lot adjacent to their big home. On the other side of us lived my aunt and uncle and two cousins. Grandma cut a tennis court out of a hill on their property and everybody in the area used it. We also had a river on the property, which we dammed up for swimming. All our friends joined us.

"I remember the hill near the house was solid with wild violets every spring. Teachers

Today, many marinas dot Gull Lake's shoreline especially in the Bay View area shown here. (Lee Griffin photo.)

The Allendale Hotel at Gull Lake, c. 1909. (Courtesy of the Richland Community Library's Local History Collection.)

often brought their classes out to our place to see all those beautiful flowers.

"Grandmother was a darling person. She had enough money to take us to New York to visit Mother's sister (Aunt Mabel) when we were a certain age. We liked going with Grandma to see Aunt Mabel because she had a chauffeur and an upstairs maid."

Mig graduated from Western Michigan University in 1926. She taught physical education in Detroit and roomed with her sister, Janet, who also began teaching the same subject a year earlier. After 40 years of service, she and her sister retired.

"Janet thought she wouldn't be able to teach physical education 40 years through retirement so she enrolled at Columbia University and took a course in library science. When she came back she worked as a school librarian for five years, then retired."

Mig points to the upright piano sitting in living room. A cartoon, cut out from a magazine, is propped in the music rack.

"I love this piano and have taken lessons in Kalamazoo. I also played for the little dances I taught at school, just a few little notes here and there. When I moved out here at the lake, I decided to buy a little organ and a piano.

The cartoon is typical. It says, 'I always knew my piano teacher was religious because every time I sat down at the piano, she said,

Twenty-seven-year-old Margaret McKenzie taught physical education in Detroit, c. 1934. (Courtesy of the McKenzie family.)

"Oh, God!'" That's me, exactly. None of us in the family were very musical. At Christmas time we had to sing carols, but with our voices sounding like they did, I don't know how anyone kept a straight face. I do have friends, though, who come out to visit and they stand here and play my piano.

When Janet and I were teaching it was the time of the Depression, but we didn't notice anything different because the school paid us in script. We paid our rent with script and all the department stores accepted it. We even bought a canoe from the Old Town Canoe Company in Maine with script. My sister and I were making more salary than all of the boys we knew during this time. We had everything we wanted so the Depression didn't affect us; it had quite an influence on people who weren't teachers, though.

JULY 4th,
Picnic and Dance
At Cottage Hall, HAWK'S Grove,
GULL LAKE!
Dance will be Run on the Bowery Plan.
10c. Single dance, 3 for 25, or $1.00 for afternoon and evening. Hall is 28x61 1-2, first rate floor, GOOD MUSIC in attendance, and good order preserved.
STEAMER CRYSTAL,
Will be run all day and evening.
GOOD SUPPLY OF ROW BOATS.
No meals furnished at the grove. Meals can be had at Lake House and private houses. Bring your families and have a jolly day at the Lake.
E. L. HAWKS, Prop.
N. R. SCUDDER, Floor Manager.

This poster advertises the upcoming Fourth of July activities being held at Hawk's Grove, Gull Lake. (Courtesy of the Richland Community Library's Local History Collection.)

Everyone loved to come to our apartment for parties, because their parents didn't have much money to entertain. This made it really fun for us because we entertained a lot."

Mig never became an administrator throughout her long teaching career. She believed such a move would limit her travels.

"In Detroit, the district and school principals wanted me to go into administration. They sat down at my desk one day and said, 'We have good news for you, Mig. We're going to make you assistant principal.' Well, they took one look at the expression on my face and asked me if I weren't excited. I told them no, I wasn't and explained to them if I took the job, I couldn't take three weeks or a month of vacation time to go on trips. They told me they understood, now, why I wasn't excited by their offer. Even though I turned the job down, I had the great pleasure of knowing they had asked me.

"I've been to more than 67 countries and this is how I managed that. Every June, I borrowed from our teacher's credit union, took a trip with the money and then paid it all back the next year. The following year I repeated all over again. A friend of mine did the same thing and together we traveled all over the world together. I also went on dozen or more trips with my sister, Janet. Actually, I liked every country or place we visited, so I had no favorites.

"I loved the Nile, the Orient, Portugal, the Amazon, Russia, Afghanistan and Iran. They were all good trips. We hired people who planned the trips for us and they knew what we liked and what we could afford."

Over the course of her travels, Mig met several famous people. She cites two of them.

"I met President Eisenhower. He came to the Women's City Club in Detroit when we had a meeting there. I also had a friend in Hollywood. I went to a party with her and in the course of the evening I told her there was a guy who looked like the actor Dick Powell. She told me it was him and I asked her why she didn't tell me sooner. She didn't think I was interested. She was right. I'm not one to go with people like that. It doesn't

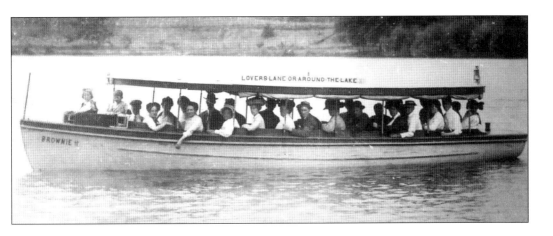

The Brownie II *was one of the many tour and excursion boats plying the waters of Gull Lake in the 1890s. (Courtesy of the Richland Community Library's Local History Collection.)*

interest me. They wouldn't pay attention to a little gal from Kalamazoo, anyway."

Mig explains that she acquired her nickname from a friend she knew at Woodward Elementary School in Kalamazoo.

"She came here on a visit from Florida along with other guests. When she heard someone call me, 'Meg,' she made the correction and added, 'It's Mig, because I named her.' She explained that the two of us would go to the playground after school before going home and would shoot migs with marbles. I never knew whether she really did name me or not, but she insisted it was true."

Mig holds no misgivings or regrets that she never married. There were several prospects, however.

"There was one chap I just loved, but he changed jobs and moved out of the area. I was going with someone else, anyway. He finally came back to this area and got married. A short time later he died coming back from a cruise. Another guy I was very fond of went to Chicago, then out west and became a multi-millionaire. I saw him in Palm Springs. Someone asked why I didn't marry him and another person said it was because he was Jewish. At that time it made a big difference.

I've been so busy all my life and most of

my friends have husbands. It's not like a lot of old widows or old maids running around, so I don't think I missed out on anything by not being married. There is not one thing I wanted to do during my lifetime but didn't. I've done everything I could. I've been on friends' boats and sailed all around the Pacific. Now I am so old, I don't look forward to doing anything else. I can just sit back with my memories.

I always went to the Congregational Church in Kalamazoo as a child. Mother and Dad were matron and patron there. I never joined until I retired and moved back to this area. I still belong, but I don't attend church very much. I'm not unhappy about that because I think I live the life of a good Christian.

As for believing in an afterlife, I don't think about it. I guess I don't believe in an afterlife. Well, I guess I do. I had better find out soon, hadn't I? I occupy my time with lots of things besides putting on parties. I played golf regularly until two years ago when I broke my hip. I gave it up then, but not because I had to. The surgeon said I could still play golf but not tennis.

I also belong to the Ladies of the Lake, the Gull Lake Country Club and two bridge clubs."

Mig compiled a history of the Ladies of the

Lake from 1952 to 1998. She designed the cover, had the booklet printed and gave one to each of the group's members as a Christmas present. Through their various social activities and parties, the Ladies of the Lake has donated funds for nursing scholarships, the March of Dimes, the Cancer Society, Radio Free Europe, and the township fire department.

"I am still driving my car, but they probably won't let me, shortly. I've never been in an accident with my car or anyone else's, which is just lucky. I stay young at heart because I keep busy all the time, have lots of friends and parties and fun. That has a lot to do with it, I think.

The funniest practical joke I ever played on someone was at one of my April Fool's parties. I had eight people around this particular table. They sat down for a luncheon and tried to pick up their knives and forks, but couldn't.

I had sewn them to the tablecloth. Everyone went into hysterics because we had to get the scissors and cut them all off.

I make my own Faberge eggs. After I went to Washington and saw an exhibit of them, I was determined to make my own. All my friends gave me their junk jewelry and I created 20 of them. I bring them out at Easter time. I also make all my own cards. If it's Easter, I make those. I just finished with 35 St. Patrick's Day cards. I get the paper and envelopes. Then I cut out pictures from other cards or magazines, do the borders, put sparkle on and paste pictures. I have boxes of cards for every holiday. I sent these to all my friends. It's a nice way to keep in touch.

For me, it is not difficult to be age 92. For someone who is not in good health, it could be hard. I do think nursing homes are the best thing that ever happened. Janet got sick when we were in Hawaii. When we got home the doctor said he thought she should go into a nursing home because she was failing and I wouldn't be able to care for her. The nursing home he recommended was rated tops by the newspaper. Good nursing homes have so much to offer, I'm all for them. I was glad when Janet went there. I am in good health. I can travel all the time."

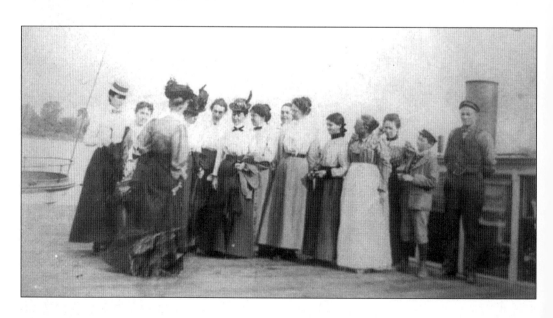

This group of ladies from Cincinnati, Ohio, are ready to embark on a lake excursion on the Michigan. On the right is Captain Martin H. Brown. (Courtesy of the Augusta McKay Librarys Historical Collection.)

Dorothy Culver

Dorothy Culver is a frequent visitor to the Kalamazoo area where she has relatives, c. 1999. (Lee Griffin photo.)

Dorothy Culver, 92, is a native of Ohio, but she spends a great deal of time in Parchment (near Kalamazoo) at her stepdaughter Betty's home.

She wed her first husband in 1928 and remained married for 33 years when he died of a ruptured aneurysm. Two years later she married a widower, Betty's father. She was acquainted with her second husband's late wife.

I first interviewed Dorothy in Parchment at the suggestion of her granddaughter, Robin, with whom I am acquainted.

It is a warm June day when we sit in the living room and chat. Dorothy has been visiting for a week.

"Betty's father and I were so lonely and it worked out fine. Oh, I am so glad I have a step-family. They are just wonderful. You often hear about step-families who ignore the second wife. It's just the opposite with me.

"I don't have a middle name. I was the last of four children and I think my parents ran out of middle names."

Dorothy was born and raised in Salem, Ohio. The family lived in town.

"Even though we lived in town, I had Billy, a Shetland pony and I played cowboy. That was my ambition until I was 11 years old. This was before automobiles.

"I used to jump on Billy and take off. My dad bought and sold ponies several times, but he kept Billy. He was so cute and frisky. Mother was scared to death of him. He got sick and had a sore throat, so my mother put something on his long neck and doctored him. After that he was just like a pussycat. My parents were getting embarrassed because I was getting so big and was still riding Billy. They sold him and it nearly broke my heart. Even though we live in town, most of our neighbors also kept a horse or pony and a few chickens. In fact, one neighbor, not far away, kept a pig."

Dorothy used to ride Billy in parades and she often won prizes. She especially remembers Decoration Day in Salem.

"That was a big day, and boy, did they have a big parade. If you were in the parade, you marched with the others to the cemetery to put flowers on the graves. Then parade participants were given tickets to the movies held in the afternoon. We'd come home and eat dinner at noon and then go to the movies. It was a wonderful time to grow up."

During Dorothy's youth very few women entered the work force. The few women that were employed included dressmakers and store clerks.

"My own mother never worked outside the home and I don't think any of Mother's friends did either. Mother was a dressmaker before she married my Dad, but sewing for us three girls kept her busy.

"She made all of our clothes like blouses, petticoats, and panties. We wore muslin panties and she crocheted lace on them. She also made for us what was called middy blouses. I had a navy blue one made of wool. It was trimmed with gold braid. A black scarf was tied in the front. I also had white middy blouses, which were trimmed in blue or red braid. We wore them with long skirts. The fancy blouses trimmed in lace were called shirtwaists. Mother made those for us, too. I remember we were shocked when girls kept wearing skirts shorter and shorter. Now girls have those mini-skirts on and when they sit down...I get so sick of looking at those bare behinds.

We didn't have supermarkets, but there were many specialty shops. If your family needed meat, for example, you bought it at a butcher shop. Most butchers had slaughterhouses located outside the city limits where they killed their animals and processed the meat.

"Grocery stores carried only groceries. They had no milk and very little produce. Sometimes they carried potatoes and apples when they were in season. If you needed milk, cheese, butter, and eggs, those items were purchased at dairy stores."

In the fall, Dorothy's family oftentimes purchased bushels of apples and kept them in their cool basement where they remained in good condition until December. Cabbages, turnips, parsnips, and other root vegetable

The Upjohn Company of Kalamazoo as it appeared in the 1950s. As the result of several mergers with other pharmaceutical firms, the company is now known as Pharmacia. (Courtesy of the Rick Shields Historical Collection.)

were stored in barrels or bushel baskets.

"After the vegetables were put into containers, they were buried in dirt outdoors. Oh, did they keep nice, almost until spring."

Dorothy attended school in town, which was located several blocks from her home.

"I can see it yet: a large, red brick building with six classrooms on the first floor and a great, wide-open stairway to the second floor. It was a beautiful building, but it was also a firetrap, with all that wood, you know. In those days, everybody walked home for lunch. If you were going out in the evening, you walked back downtown, about eight blocks away."

Riding streetcars was another option. As a youngster Dorothy often climbed onto the streetcar alone and traveled to Leetonia where her relatives met her with horse and buggy. After visiting for a week she hopped

aboard another streetcar and headed home.

"The arrival of streetcars made the farmers happy because they could ship their milk and other goods to market easily. In fact, many farmers pitched right in and helped build the rights-of-way. There were stops all over. If you wanted to catch a ride but weren't at an official stop, all you had to do was wave and the conductor would bring the streetcar to a halt.

"While I was visiting in Leetonia, I rode the streetcar all over town. During that time I never heard another passenger swear or say anything off-color. I was eight or nine-years old. Can you imagine letting a little kid do this today? Heavens no.

"In high school I just had a ball. I didn't study much, but I always passed. There was no swimming or other activities as there are now, but I played basketball in my freshman year. I could shoot baskets very well.

This is an early advertisement indicating Upjohn's focus on quality in its pill manufacturing process. (UPJohn Company Photo photo.)

"I liked the boys. I guess the boys liked me too, because I always had someone to go out with. There were 116 students in my graduating class, the largest ever.

"My favorite subject was English. I didn't like math. I wasn't very good at it, but when my first husband owned an auto repair business, I had to do the bookkeeping. It was just murder, but I did it. This was before computers."

Dorothy's father worked in a factory. Since he had a steady job during the Depression, her family wasn't greatly affected. Dorothy conceded that World War I made more of an impression.

"It was the rationing I remember. You couldn't get flour and sugar. Since my mother baked bread at that time, she had to take rice flour and other ingredients to come with something that resembled wheat flour. She tried to make bread with that. It was awful, but we ate it anyway."

Throughout high school, Dorothy worked in a confectionery store and earned the funds to buy schoolbooks and clothing with enough left over for spending money. After she graduated, Dorothy enrolled in nursing school. However, within a year, she met a young man and fell in love with him.

"I met him on a blind date and that was it. I fell like a ton of bricks. He fell too, because after that, neither one of us dated anyone else. We were married several years later and I never regretted it. I would marry him today, again, if he were here. Not many people can say their marriages were that good. He was a wonderful man."

World War II was raging when Dorothy's spouse started his garage business. She was his bookkeeper. Her family, which now included a son and daughter, experienced rationing again. Her husband, Ben, was of draft age but didn't get inducted because he had lost an eye.

"People would come into the garage and ask Ben why he wasn't in the Army. He'd say it was because he only had one eye. They wouldn't believe him because he wore an artificial one.

"Also, he was in what was called an essential business. You couldn't buy a new car because materials were scarce. You had to keep the old junkers going. In those days, a car with 50,000 miles on it had to be overhauled. Today, my car has 75,000 miles and it still runs good.

"Anyway, feelings ran very high if anyone thought a man was a slacker during the war."

Ben died at age 57 from a ruptured aneurysm. Their son died of the same condition and at the same age. Doctors

believed the condition was inherited. Moments later, the tears begin to flow from Dorothy's eyes. Her voice quavers when she talks about the death of her 11-year-old daughter. Time has not diminished her grief.

"The death of my daughter was the worst time of my life. The rheumatic fever developed suddenly. It's an infection which affects people differently. It damaged the valves in my daughter's heart. This was in 1946 when antibiotics were first being discovered. Sulfa was in use, but it didn't work very well. She didn't make it.

"I never did get over her death. When you lose a child it is different from losing a husband. My husband's death was an awful shock, too, but you finally get over it.

"A child can never be replaced. I was out of commission for nearly a year. I just kept going through the motions of living.

The first president Dorothy voted for was Calvin Coolidge when she was 21 years of age. She comments on Coolidge and other presidents who held office during her lifetime.

"Coolidge wasn't very well liked but I think he was a fairly good president. I didn't like Roosevelt at the time, but as I look back, I think he did a lot of good. When he was elected they blamed the whole Depression on President Hoover. I don't know whether it was his fault or not.

"I was thinking the other day about a decent president and I thought of Dwight D. Eisenhower. Jimmy Carter was a decent man, too. I don't know whether he was a wonderful president or not, but he was a good, honest man.

"Harry Truman was another good president. At the time I thought he was little coarse, but I've read about him since and he was one of our better presidents. He did good work and no one pushed him around. Like he said, 'The buck stops here.'

"I don't like Clinton. The things that girl's told turned me against him. He was such a slacker during the Vietnam War that the American Legion is against him. Oh, heavens yes. He must be smart, though, because he was a Rhodes scholar. Still, he has a flaw someplace, and I think Hillary knows which side her bread is buttered on."

At 92, Dorothy considers herself in better shape than many of her octogenarian friends.

"They don't drive anymore, and several live in nursing homes. I still live by myself and do my own laundry. I go up and down stairs and have never broken a hip. Thank goodness, not yet.

"I am really independent. I go to bed and get up when I want to. If I can't sleep, I get up in the middle of the night and turn on the television or else I read. If I were living in someone else's home, I wouldn't dare do that. I want to hang on as long as I can.

The Kalamazoo Institute of Arts features a permanent art collection, traveling exhibits and a variety of classes available to the public. (Lee Griffin photo.)

This old postcard depicts a scene on the Kalamazoo River. (Courtesy of the Augusta McKay Library Historical Collection.)

"I don't do much exercise, but I get up and walk around the house then go out in the yard and pull up a few weeds. I'd like to walk around the block, but I'm a little shaky on my feet. In the wintertime, I sometimes go down to the cellar and walk back and forth—just to get the kinks out of my legs.

"I can drive better than I can walk. I drive to the grocery store in Columbiana, where I moved with my second husband, before eight and nine in the morning, before the crowds get there. Then I go to the drugstore, which is downtown. I can park in front.

"I also pick up another lady and drive to church on Sunday. She drives, but is very timid about it. The quilting group I belong to meets once a week and I drive to that. Then I get tired and go home. I do enjoy it, though.

"I have this paper from the insurance company for my doctor to fill out. The question on the form is, 'Did you ever tell this patient not to drive? In your opinion, is this patient capable of driving?'

"Insurance companies would like to cancel your policy when you get older. Oh, gosh. I always say if they take my car keys and my checkbook away, I really know I've had it."

When Dorothy attended her 50th high school reunion, many of her classmates had passed on.

"Shortly after that, my classmates dropped off like flies. Out of 100 students, I think I am the last one left. I don't understand it, but here I am. I don't have any fear of death, but sometimes, I would just as soon get it over with. My Christian faith tells us we'll meet all the departed ones. It's a nice thought."

Sister Josephine Karas has served the order of the Sisters Servants of the Immaculate Heart of Mary for over 60 years, c. 1999. (Lee Griffin photo.)

Sister Josephine lives in a retirement complex located in the south central Michigan community of Marshall, home of one of the largest national historic landmark districts in the United States. The designated district comprises more than 850 homes and businesses.

In the late 1830s, the city was nominated as the state capitol but lost out to Lansing. Also during the 19th century, the town became known for becoming a station on the underground railroad, establishing the school system as part of the state constitution, and for founding the Brotherhood of Locomotive Engineers, a strong railroad union.

Today, the downtown area is bustling with small antique and gift shops and specialty stores.

On the day of our interview, Sister Josephine, 79, meets me in the reception room of her building and escorts me to her apartment. Along the way, elderly residents, some in wheelchairs, others moving slowly with canes or walkers, call out greetings. Sister knows everyone by name.

Sister Josephine, who has four siblings, has been a member of the order of the Sisters Servants of the Immaculate Heart of Mary for over 60 years. She remains active, but plans to retire within a year.

Josephine was born in Long Rapids, Michigan, approximately 15 miles west of Alpena, in a house built by her grandfather.

"We moved quite a bit when I was young because my father was ill with tuberculosis. I was five years old when we moved to a farm in North Dakota. That was where my father was from and it was thought the good, fresh air would be ideal for him. We were there only two years, because by the time I was seven, we moved to Battle Creek. Two years later, my dad died.

"The family settled on Battle Creek because my mother's sister lived there. They had come down from Alpena in their younger years to work at Post and Kelloggs, the cereal companies. Then too, my mother and dad first met at Fort Custer (near Battle Creek) during the war.

"After Dad died, Mother was fortunate that he had been in the service because after he died she started receiving a pension. Let me tell you, it was meager, just kind of held us together. Mother raised us five children on a shoestring.

"In Battle Creek, we moved in with Mother's youngest brother and my grandmother. Grandmother died a short time later and my uncle stayed on. Since my dad was gone, our uncle was just a wonderful surrogate father. We couldn't have asked for anyone nicer and he didn't have to do all the things he did. He always managed to find an extra nickel here and there and gave it to us. Whenever he was working, he always gave Mother money for room and board, too. That held us together."

Josephine graduated from St. Philip Catholic High School in Battle Creek in 1939. She found a job as a nanny for a family with two children. She stayed there until spring.

"I always say that's when the Holy Spirit hit me. Just out of nowhere, I just knew I had to be a Sister. We were a religious family and went to church every week. Mother prayed every night. My sisters, brothers, and I would sit around the kitchen table doing our homework and Mother would be in the living room praying. She wasn't fanatic, but she had little prayer books. Once I can remember saying, 'Mother, what do you pray for all the time?' and her answer was, 'I pray that all my sons will be priests and all my daughters will be Sisters.' I didn't question her again. I just thought, well, that's interesting.

"She did her best to try and keep us on the straight and narrow path and to be a good mother. She never held a job outside the home so she was always there for us."

Josephine didn't know what she had to do to become a Sister, but thought the best way to find out was to talk to one. She singled out a Sister she had in high school.

"She was just lovely, and I really liked her. I stopped in one afternoon to see her and she suggested we go talk to the Mother Superior who was in the house. I talked to her a bit and then decided to go to Monroe, Michigan,

46

when school was out.

At the end of the school year, all nuns went back to live and study at the main convent in Monroe until school started again in the fall.

"We went back to talk with the Mother Superior one Sunday morning after mass, and she realized my mother was very much in accord with my wishes. I wanted to go to the convent in June but Mother Superior wouldn't let me. She said the deadline was July 2 and that I had better stay home until then.

"The deadline to enter the convent was on a Tuesday, I remember, and we only had one car. We were lucky to have that. The 30th of June came on a Sunday, so my uncle drove us (my mother and sisters) to Monroe. My goodness, that was 60 years ago.

"For six months we were postulants. That's very preliminary. You check them out and they do the same. It's a double deal, there. You are given a little rule book and you and told what to do and what is expected of you. For six months, that's what we did. On that first Monday morning I went to school and I've been going ever since. That was beginning of the summer session.

"The order was connected with Marygrove College in Detroit, so those instructors would come down to the Mother House in the summertime to teach us. It was the first of many courses we needed in order to become teachers. We were a teaching community. Everyone who came into the order became teachers. That's all we did. There was no nursing, social work, or anything else. Today, that has all changed.

"After six months of, shall we say, inventory, we became novices. At that time we received the long, blue habit and a white veil which distinguished us from the sisters who had taken vows. Everyone in Detroit knows us as the IHM's (Immaculate Heart of Mary). We were the only ones who wore blue habits so we were known as the blue Sisters.

"We were the youngsters in the religious community and there were approximately 96 of us, all young women from the age of 18 to 22. We continued school everyday. It wasn't like regular high school because

Marshall's Honolulu House was built in the 1880s of Italianate, Gothic Revival, and Polynesian influence. Today, it is the home of the Marshall Historical Society. (Lee Griffin Photo.)

Sister Josephine, c. 1990, celebrating 49 years in her religious order. (Courtesy of the Karas family collection.)

when we weren't taking classes we worked in the religious community. We washed the windows and we scrubbed the floors. We peeled potatoes, cleaned vegetables and served the food. We did whatever had to be done.

"It was a nice group. Oh, you really got to know the Sisters. You formed friendships and it was wonderful. Everyone there came for the same purpose. At the time, I didn't know I was going to be a teacher. No one told me that. We all ended up being teachers."

After she spent two years in the novitiate, Josephine professed her temporary vows, comprising three additional years.

"We were called the 'temps.' We received the black veil and we entered the (religious) community. Prior to that we were not allowed in certain areas of the building. Now we were official and any place was ours."

"Temps" continued their schooling. By the time many of the Sisters had completed two years in the novitiate, they received temporary

teaching certificates. After final vows were professed, the nuns were sent out on missions. Prior to Josephine's profession of final vows, she went on an eight-day retreat. There she learned her first mission was in Akron, Ohio.

"That first morning in Akron, I went down to the chapel where we had meditation and prayer. Right away I smelled rubber burning from the Firestone Tire plant and I thought, Oh, I'll never get used to this. The fumes were terrible. After while, though, I got used to it."

When school was out in the summer, Sister Josephine returned to the Mother House in Monroe, Michigan, and continued her schooling. She needed two more years to earn a degree. It was during this period that nuns receive their assignments for the following year. Sister Josephine learned she was being re-assigned to the St. Gregory school in Detroit.

"I was at St. Gregory for just a year. I had fourth grade. I was among 26 Sisters, all of whom were young so we had a good time. We lived in three houses, but would all get together in one house to eat, another to sleep in, and the third house to pray in. We really enjoyed ourselves."

Then Sister Josephine came down with appendicitis. After surgery, she recuperated at Marygrove College's infirmary. That summer she returned, along with the other Sisters, to the Mother House, where she learned that her new assignment was to remain there.

"I didn't know what I was to do there, so I went to the Mother Superior in charge of the house and she told me I was to help with the work in the main kitchen, an enormous place.

By that time, the war had broken out and it was very difficult to find help. Women were moving into the factories for the first time. Anyway, I was good at cooking; my mother taught me. I felt badly, though, because I wanted to be out teaching. But, you get over it.

"There were six of us Sisters who worked in the kitchen. Two of them were in charge. We tried to be creative but sometimes we had

flops.

"*A baker from Toledo came in each morning to bake bread, cookies, cakes, and all sorts of desserts. Eventually, we got a chef. He took over to planning the menus and cooking the meats.*

"*There was always lots of work to do in the kitchen, because there were 200 Sisters living there and perhaps 400 students. As it turned out, I was there four and a half years. Those were the most wonderful years of my life— beautiful years.*

"*I took my final vows in January, 1946. This means you make your commitment for life. There was a nice celebration, but parents don't come to it. No one comes to the final vows ritual; it is a religious community affair. The other two ceremonies (postulants and temporaries) are for family and friends.*"

Subsequently, the General Superior (now titled President of the Order) told Sister Josephine her new assignment was teaching at St. Raymond School located at the east side of Detroit.

"*The General Superior is the top person, the one over the whole religious community. She was a beautiful person. Then there is a council, made up of people who advise her. When she told me they needed a teacher at St. Raymond, I was happy as a lark.*"

Throughout the years Sister Josephine taught at various schools throughout Michigan, Ohio, California, and Minnesota, and in many cases classroom sizes exceeded 65 students.

"*It took every ounce of strength and energy to teach that many children, not to mention all the ingenious methods I tried to keep all these kids from getting into trouble. I don't think I could do it today. I was stern in the classroom, though. You had to be. We just didn't have time for youngsters to misbehave.*

"*I've never had any misgivings before or after I took my final vows. When I first entered the convent, I knew this was what I wanted to do. I never wavered. Never.*

"*At the time I entered, I wrote my two sisters—who used to follow me around which was so irritating—and told them if they*

The Brooks Memorial Fountain in Marshall has 96 variations of color. In 1930, the fountain was designed at the request of Mayor Brooks in memory of his father. (Lee Griffin photo.)

wanted to follow me now, it was okay. Well, both of my sisters came to the religious community, but one of them stayed a short time and then went home. The other sister stayed on and has been in the order for 25 years. She's Sister Vivian who lives in Jackson. None of my brothers became priests. Poor Mother."

In her 50 years of service, Sister Josephine acknowledges that she has witnessed many changes in dress for Sisters and priests.

"*Today, whether or not to wear a habit is a Sister's choice. In the early 1960s, the Holy Father said the religious should wear clothing appropriate for their ministry. That was all we needed in my community. I had been missioned at St. Alphonsus school in California when a letter came out which said any Sister could experiment with secular clothing. I wrote my name down and sent it in. I had a seamstress measure me and she fashioned a blue skirt and jacket,and a white blouse. An older Sister also signed up with me*

Sister Josephine at the Mother House in Monroe, Michigan, with her sibling on the left, Sister Vivian of Jackson, Michigan, c. 1991. (Courtesy of the Karas family collection.)

"I remember it was the night of open house at the school and thought this would be a good time to get things moving. The parish pastor and his assistant said, 'Before you show the public your new outfit I want you to show us.' So Sister and I modeled our clothes for them. Of course, they looked at us and laughed a little. Later, we went to the open house and we were the only two Sisters dressed in civilian clothes. The others were still in their long habits."

From then on, Sister Josephine has dressed in civilian clothing. In the late 1970s she gradually added more color to her wardrobe.

"Shortly afterward, almost all the Sisters traded their habits for secular clothing and at the Mother House today, only ten of the older Sisters continue to wear the habit.

"Priests have always been more relaxed in this area as they have for years. Usually they wear slacks and sweaters while working in their offices. However, when they go out in public on church-related business or when

they make hospital calls, they generally wear black or gray suits and clerical collars."

Sister Josephine was assigned to teach junior high school math in Battle Creek after she requested a transfer in order to remain close to her mother was ill and partially blind. However, trying to care for her mother and teach proved impossible so she asked for another position which allowed her more time. As a result, Sister Josephine was assigned to St. Mary's Catholic Church in Marshall where she performs pastoral ministry. Her duties include visiting elderly or sick parishioners in homes, hospitals, and nursing homes. She also runs bingo games for senior citizens and assists her pastor with the Right of Christian Initiation of Adults (RCIA) program for persons who wish to enter the church.

"Faith is so illusive. We let them know what the Catholic church does and what its beliefs are. If you like it, come on in. If you don't want this, fine. You don't have to come.

"I also run an instruction program for parents who desire baptism for their children. This is a refresher course for parents raising their children in the Catholic faith, because we realize many adults never learned or remembered much of the religion they received in school.

"In retrospect, the most rewarding aspect over these 50 years is belonging to this religious community. I'm 100 miles away from the Mother House, but I feel very close, just like family. This is a close-knit group of people who have the same ideals and principles who want to serve the people of God. This is all we do.

"I believe it is regularity in my life that allows me to remain active. I try to keep a schedule and maintain a good diet. I also think my being around young people keeps me young. Some of it has to do with genes, as well. All five of us (siblings) are still very young. Actually, I just don't feel as though I'm 79. I believe I can do—whatever.

"Ultimately, I don't think any religion or denomination has a priority on heaven. We all have to believe in the God we know and to love Him and our neighbors as best we can."

HARRIET DeHAAN

Harriet DeHaan spent 37 years in education, c. 1999. (Lee Griffin photo)

By the time Harriet DeHaan retired from her job as principal of South Westnedge Elementary School in Kalamazoo, she had chalked up 38 years in education, of which 25 years were spent as school principal.

Harriet was born 92 years ago in Mankato, Minnesota. She is the youngest child comprising a family of five daughters and one son. Her father was a native Norwegian who came to the United States in 1818, to attend an agricultural college, known today as the University of Iowa. He mother also had Norwegian roots.

Harriet's father became a horticulturist and the family moved to northern Wisconsin and later to Michigan.

Prior to our meeting, I hadn't known Harriet, but I knew she was a principal because my first job after graduating from Western Michigan University was teaching elementary physical education in the Kalamazoo School district.

A mutual friend suggested I talk with Harriet because she knew Harriet had lived through the 1918 flu epidemic.[1]

"It was fall and I was 10 years old when the flu hit suddenly. It was the deadly type of Spanish flu as they called it. The milder cases were called the la grippe. It's an old term.

"Well, I went downtown shopping on a Saturday morning with my mother and sister. I was going to get a new pair of shoes which was a big event. I got the shoes and was going to do more shopping with them when all of a sudden I got sick.

"My mother sent me home. My sister May, who was five years older than I, was already home sick in bed with the flu, as was my father.

"By the time Mother got back home, I was running a high fever. For three weeks I was in bed. I couldn't eat much, either. The doctor came to the house but he didn't have any medicine except quinine. Doctors went to the houses where people couldn't get out of bed and leave quinine and a glass of water beside the bed. People developed pneumonia and they died like flies. You'd look out the window and see people carrying your dead neighbors

out. Then you'd lie back down in bed because you were too sick to care. We lost a lot of neighbors. You didn't know who was alive after you got well.

"The schools were practically closed and everything slowed way down in the factories because so many young and old folks were sick. It lasted months and months. It was so contagious. The only vaccinations they had were for smallpox and everyone thought that was wonderful.

"During this period, my father came down with the flu twice, but my mother didn't get it. Then one day, Mother started talking about the epidemic and all of a sudden she lost her voice. That's how it came on her. She recovered, but I found out my mother-in-law lost her voice during a bout with the flu and never recovered it beyond a hoarse whisper. She had a beautiful singing voice, too. That was sad.

Harriet wed in 1929, just before the Crash. She describes how tough it was.

"You can never forget the Depression. I have friends in the same age bracket who feel the same way. The banks closed. All the money you had was in your purse or pocket. Whatever funds you had in the bank you couldn't get. In some cases, you got nothing back.

"My husband, who was 30 years old at the time, was in the home and commercial building business with his father. They had built up a nice business. We lost everything. We lost our nice new house, the money we invested in the property we had and the bankroll we had to have in order to be in business."

It was during the Depression that Harriet returned to college to get a degree in education. She had previously earned a two-year life certificate for teaching.

"I couldn't get a teaching job because I was married. You could teach at a country school for $30 a month. I had friends who did that and lived at home.

"This was just one of the factors of the culture. Married women just didn't work. It was thought women took jobs away from

men. For example, if you were a teacher and got married on Saturday, the contract you had with the school was null and void on the following Monday. Your job was gone. Then after employers started hiring women, they wouldn't let a man and his wife work in the same place.

All that changed when the war in Europe began building up. Harriet explains:

"The U.S. was building war goods and furnishing it to France and England. Germany hit so fast we speeded up the war effort here. Many single men teachers were drafted. Lots of women enlisted and were driving trucks for the Red Cross. That's when they called on married women.

"It wasn't long before school recruiters started boarding busses and trains, tapping people on the shoulder, asking how much education they had. They said they were hiring for teaching jobs at $100 a month. That's how women got into the work force.

"For a woman who wanted a profession back then, there were three choices: nursing, secretarial work, or teaching. I always loved children so I debated between teaching and nursing. The children won out. I always loved children and I still do, above all else. If you

understand them and know what to expect, they are most interesting and are still developing."

Harriet reveals what she considers the highlight of her 38 years in education.

"My last assignment before I retired was principal at the South Westnedge Elementary School, which is located on Westnedge Avenue, one of the busiest streets in Kalamazoo, with bumper-to-bumper traffic most of the time. It has a pedestrian bridge. And it was my little third graders who got that bridge.

"At the time, Westnedge Avenue was the main track into town. All the trucks came in that way. We had to have a school crossing guard out there because the traffic was terrible and many of our children had to cross from the other side of the street. The third grade class, their teacher, and I went down to the city commission meeting and made a plea for safety. Well, the city commission claimed that U.S. 131 was about to open and it would take care of the truck traffic. The kids went outside every day at the same time and counted cars. They did this for several weeks to get a count. U.S. 131 opened and nothing changed. The kids also counted cars after 131 opened and the traffic was just as bad. The

South Westnedge Elementary School children and their principal, Harriet DeHaan, were responsible for the city constructing this pedestrian bridge across busy South Westnedge Avenue. (Lee Griffin photo.)

Today the Kalamazoo County Building still houses some Circuit and Probate and District Courts and related offices, c. 2001. (Lee Griffin photo.)

youngsters put all these before and after statistics on charts and we all marched down to the city commission meeting again and presented the material. As it turned out, the commission was convinced and the children got their bridge. The city even had to purchase land across the street in order to install it."

Harriet concedes she has witnessed many changes in children and parenting over the years, and offers some advice.

"Today, there is too much permissiveness. This means many youngsters have little or nor respect for the law when it comes to people and their property. Also, kids are becoming more violent than ever before, and I attribute this to movies and television. Movies didn't used to have the violence and foul language you find today. Television has opened doors to violence and acceptance.

"Parents believe they can control what their children watch, but when they are working and not at home, they can't control it at all.

"In order to correct some of these problems, it has to start in the home. Parents have to develop standards. If parents would talk to

their children and find out where they are going and who they are going with, and what is happening, parents can protect them. It has to be done through love, not through aggression or force.

"It's a serious commitment when you have a child because you are responsible for a life and what will happen to it. In my estimation, the biggest and most important aspect of a parent's life is to bring up a child. It is a lot of work. I used to tell parents to hang on a little longer and they would see it pay off, because many mothers felt like walking off—and some of them did just that."

Harriet describes her current interests and activities as well as her limitations.

"I'm a read-a-holic. I still take many college courses of which I've taken more than 70 since I retired in 1972. At my age, I don't have to pay tuition. I took a very strenuous five-year, international Bible course and last fall I took one in American ethics and another in geography. You name it, and I guess I've taken it. If you don't use it, you lose it. That's true with the physical being, too.

"I always can lots of tomatoes. This year I canned six or seven bushels, which made over 178 quarts. I went to my daughter's house and canned them. I peeled the tomatoes, put them in the jars and then into the canner. When they came out, my daughter took charge of them. She is a sort of go-fer who cooks the meals."

She is one of the few individuals her age who seldom wears glasses and does not own a hearing aid.

"Both my eyesight and hearing is very good. I still do everything I did when I was younger, only not as much or as fast. I've always done the painting and other fix-up jobs around the house, but my daughter has made me promise not to climb. My balance is not as good as it used to be. You begin to accept limitations and that is one of them.

"I no longer can work six to eight hours a day digging out in the yard or planting 150 plants like I use to do. I can do some but not as much. These limitations are what I've had to fight against and accept because there is nothing you can do about it. You have to be grateful for what you do have."

Harriet also mows her own lawn, figures her income tax, performs her housekeeping chores and continues to sew. She also continues to drive.

"Of course I still drive. How would I get anywhere if I didn't? I'm super careful, though. I don't want my driver's license taken away.

"I am strong in the shoulders and arms and I've always been very flexible. Today, I can still touch my hand to the floor without bending my knees." (She demonstrates this with ease.)

Harriet attributes her longevity and energy to her diet. She admits she has learned to eat everything that grows and she's learned to like it.

"I've eaten that way all my life and I've also been interested in nutrition and health and I took a course in it back in 1930. I've followed up on everything I could.

"Both my husband and I took vitamins

A 1950 photo of the County Building known as the County Court House. (Courtesy of the Rick Shields Historical Collection.)

IF YOU VONT COME TO

KALAMAZOO

VY VONT YOU, VOT?

This sign pokes fun at early Kalamazoo's large Dutch population. (Courtesy of the Rick Shields Historical Collection.)

and minerals for years. We bought them through the mail at Sears and Roebuck. I'm convinced that is what kept him in good health and away from diabetes and other medical difficulties his family had. He was 88 when he died, a good age considering his family history."

Harriet shares her opinion of retirement homes and what she finds lacking in the elderly.

"I find that older people don't have a sense of humor anymore. We have always been a family who has joked a lot and had plenty of humor. You learn to laugh at yourself, too. Some folks have personality changes after they have strokes. Perhaps that explains it.

"Also, a few of the older ladies living nearby scold me for going out and being involved in many activities. They tell me it makes them feel guilty when they don't get out themselves.

"As for retirement homes, well, some people go there and they are the right places for them. Then I've had friends who say, 'Harriet, stay in your home as long as you can.' If I left my home, what would I do when my family comes to visit? My granddaughter lives

outside Washington, D.C. and other relatives live out of town. Why, I had eight people over here at Christmas time and I was cooking three meals a day. I was also loading the dishwasher just as I was un-loading it. Those young fellows (great-grandchildren) have big appetites. They love to eat."

END NOTES

1. *In 1918 as World War I was occupying the news, a soldier at Fort Riley, Kansas complained of aches, pains, and fever, common symptoms of the three-day flu. By weeks end 500 soldiers had come down with the disease. That summer and autumn almost two million American doughboys crossed the Atlantic to go to war. Many soldiers died at sea. Those who survived carried the disease to the war zone. The flu traveled to Italy, Germany, France, Britain, and other countries. Spain was especially hit hard (an estimated eight million) and the disease became known as the Spanish Influenza. By the time the disease died down in November, 21 million people worldwide had died, with 600,000 in the United States alone.*

H. DALE SHROYER

Dale Shroyer was an avid Chicago Cub's fan, c. 1999. (Lee Griffin photo.)

When Dale was born in 1917 at New Windsor, Illinois, the exotic dancer Mata Hari was executed by the French for providing military secrets to the Germans. In Russia, the October Revolution established Lenin as the leader of the new Bolshevik government. Back in the United States, the government acquired the Virgin Islands from Denmark and the Selective Service Act provided for the first ever national draft.

Today, Dale is known by nearly everyone in the village of Augusta, a community of 600 residents which is located midway between Kalamazoo and Battle Creek. He served on the village council as a trustee for a total of eight years, was a member of the Climax Prairie Lodge of Climax and the Scottish Rite Consistory Valley of Grand Rapids. He also helped establish Great Lakes Electronics, a firm which supplied micro switches to industries throughout the United States. Dale also served as its president. He held memberships in the Gull Lake View Golf Course and the Fellowship United Methodist Church. For years, he repaired television sets and electric appliances in his home. In good weather, he walks a couple of blocks to a local restaurant where his friends regularly meet for breakfast and conversation.

My first visit with Dale is on a cold January afternoon. He sits in his large easy chair where is working on his income tax.

"I grew up in Wooodhall, Illinois. We had three lots adjacent to our house. Back in those days, there were no power lawn movers and it was my job to mow those lots with a push mower. This was one of my chores I didn't like. The other was Mother's chickens. I had to feed them, catch them, and clip the feathers off one wing so they couldn't fly. I hated chickens.

"We lived in town so I walked to grade school which was 10 or 12 blocks from home. It wasn't bad. The kids who lived in the

Charles B. Knappen purchased this former saw mill in 1929 and it continues to operate today as one of Augusta's major employers. (Courtesy of the Augusta McKay Library Historical Collection.)

Today the Knappen Milling Company produces bran for cereal manufacturers and flour for bakeries and companies which provide blended flours. (Lee Griffin photo.)

country had to get there the best way they knew how. Some came by horse, some walked and a few by car. There were no bus facilities.

"I liked all the subjects except music. I liked all the teachers, except the music teacher. I didn't especially care for her because music wasn't much fun. Music happened to be the only subject in those days where you would get a grade. I just squeaked by on that one. I'm no musician. I couldn't carry a tune in a market basket. Never could. You are either born with it or are off in left field."

Dale and his young friends kept themselves entertained by playing basketball and baseball. Television, at that time, was non-existent.

"There was an old barn on my folks' property and since we had no horses, my friends and I made a make-shift gymnasium and played basketball in the hay mow. Every town had their own team. It was fun and we always had something to do. I always had a bicycle and I usually fooled around with cars

since my dad had a garage. I learned to drive my father's Model T Ford by sitting on his lap. Of course we didn't have driver's licenses to contend with and there wasn't the traffic like there is now, either.

"I took my first airplane ride in 1934. I was 17 years old, probably a junior or senior in high school. This was an open cockpit job which held one person in the front and another in the back. The pilot sat in the back. They were giving in Moline, so my friends and I decided to take a ride. We had to take turns. It was exciting. I thought the plane was going to fall apart with all those wires hanging there."

Dale lived with his family in Woodhall until he graduated from high school. He then moved to Moline to attend business college.

"Times were really tough. This was in 1935, the Depression years. I worked as a janitor at the business college in exchange for half my tuition cost. I walked a mile-and-a-half to wash dishes in a restaurant,

Dale at age 12 is pictured with his mother and sister, Anona. (Courtesy of the Penny and Chris Inman family collection.)

Still in existence, this coal chute outside Augusta once supplied fuel for steam-powered trains which stopped underneath to stock up on coal. (Courtesy of the Augusta McKay Library Historical Collection.)

which paid for my meals. I also worked as clerk in a motor supply store which paid enough for my room. I attended this school for two years. They didn't give degrees back then but I learned well.

"My mother was the person who changed the course of my life the most. She didn't want me to go into the garage business like my dad. I believe her reasoning was that no one ever paid. My dad had accounts receivable that would choke a cow. Those farmers, you know, would say, 'I'll pay you when I get some money.'

"Mother got good marks in school and she knew the value of a good education. Dad didn't. He liked working with his hands. He was very good at figures, though. He could add like nobody's business."

After he finished business college Dale served with the Civil Service in radio communications at Dakar, Africa; Louisville, Kentucky; Kodiak, Alaska; and the Aleutian Islands.

"We were civilians but wore Navy uniforms and dined with the officers. This was during World War II. I saw President Roosevelt up there in the straits of Alaska. He was in a rowboat."

Dale also was employed in communications at Grand Trunk Western Railroad as well as working the tower at the W.K. Kellogg Airport in Battle Creek. During his 15 year tenure at the facility, one incident stands out in his memory.

"On this particular day, I was working the tower in Battle Creek, and it was snowing so hard you couldn't see 3 feet in front of you. Well, Kim Sigler, the governor of Michigan who served from 1947 to 1948, flew in during this snow storm. Back then, we didn't have all this fancy stuff like radar and sophisticated instruments. As Sigler flew over the tower, I would tell him over the radio how loud he sounded. We repeated this several times until finally he landed safely. This occurred in the late 1940s or early 1950s. He always flew by the seat of his pants. In 1954, I believe it was, he crashed into a radio tower on the outskirts of Augusta in a

very low ceiling and was killed."

Dale met Bette, the woman who was to become his wife, at a cafeteria in Kalamazoo where she worked while attending what is now Western Michigan University.

"She was a good looking woman. That's what attracted me to her. She also was a very likable person. She had a certain way about her, just like her mother. Her father, too. She loved people.

"On our first date, I had an old Plymouth coupe car and we piled three couples in there.

We had a great time just driving around the city. The next time we went out, we went to see Gone With the Wind *at the movie theater. This was the original version with Clark Gable. Boy, it lasted for hours. This must have been in 1939."*

The couple married in 1941, and later had one daughter. The two had just celebrated their 50th wedding anniversary when his wife passed away in 1992. Several years prior to her death she was ill with cancer and had heart trouble toward the end.

Bette served for many years as Ross Township clerk and was active in the Friends of McKay Library (Augusta) where she spent

A view of the canal which runs through the center of Augusta, c. 2001. (Lee Griffin photo.)

Two-year-old Dale Shroyer poses with his favorite book in Woodhall, Illinois, c. 1919. (Courtesy of the Penny and Chris Inman family collection.)

blacksmith. He was in his early 80s when he had a heart attack while working in his shop. Nobody retired back in those days."

Dale, a 50-year wedding anniversary celebrant, has a simple formula for a successful marriage.

"There must be give and take. Nobody is right all the time. So many couples are getting divorced now because they just don't think. They have a rough spot and that's the end of it. Then they pay for it the rest of their lives. It's expensive, I'll tell you. I've never been divorced, but I know it sets people back very far, financially."

These days, Dale finds enjoyment attending church when he is able and he loves looking at maps.

"I love to sit here and look at these maps. Why, the most beautiful country I've ever seen was during the flight from Anchorage, Alaska, to Seattle during the war. The snow and mountains are breathtaking.

"I also used to collect coins and study the stock market. I don't collect anymore, but I still keep my eye on the stock market. As for pets, well, we always had dogs for ever and a day. We had several Cocker Spaniels. All of them had different characters and all were favorites."

Gardening is another favorite hobby of Dale's, but in recent years two hip replacements have curtailed much of that activity. Nevertheless, he remains an enthusiastic baseball fan.

"I used to attend many of the Stan Musial Baseball tournaments in Battle Creek, and my favorite major league baseball team is the Chicago Cubs. I went to Wrigley Field way back in the 1920s many, many times. My dad was also an avid Cub fan. The Detroit Tigers couldn't beat a carpet."

POSTSCRIPT

Dale died on May 31, 2000, as a result of injuries he received when he backed his car out of his driveway and struck the cab of a semi-truck which was parked across the street.

many hours compiling scrapbooks comprising village history. In retrospect, Dale has some regrets for not taking more trips with Bette.

"I always wanted to travel more, but never did. Bette and I didn't take many vacations. That's one thing I realize we should have done. For a few years, we went to Florida. I'd go crazy spending a whole winter down there, but a couple of weeks are all right. It certainly is not scenic at all and the only picturesque part is the panhandle. There is too much traffic and too many trailers.

"I'd liked to have gone to Sweden. It's a beautiful country. My grandfather was Gustav Anders, a Swede. His given name was Anderrson, which in Swedish means Ander's son, but when he came to the United States there were so many Anderrsons he changed it to Andreen. He was a

GLADYS X

Gladys X regularly volunteers at a women's shelter in Kalamazoo. (Lee Griffin photo)

Gladys, 88, describes herself as a private person and prefers not to have her last name revealed. We have a mutual friend, yet she and I have never met prior to our meeting.

A widow for five years, Gladys lives on the west side of Kalamazoo near Western Michigan University and Kalamazoo College. Her home is a large, two-story colonial which is more than 75 years old. She has a son and a daughter, the latter lives in Chicago.

These days, much of her spare time is spent at a women's shelter where Gladys volunteers her services, as she has for the past 20 years.

Gladys was born in the small town of Hamilton, located between the cities of Allegan and Holland. After she graduated from high school in Holland, she relocated to Kalamazoo—where her grandparents lived—to attend what was then called Parsons Business School.

"In Hamilton we didn't have much to do. We used to roller skate, ice skate on a bayou, and do a lot of coasting (sledding). We made our own good times. It seems like kids today are so supervised. Everything is planned.

"I also took music lessons as a kid. Everyone took music lessons. I played the piano and my sister played the violin. I accompanied her. We often had music memory contests, to see who knew the most numbers by heart.

"I loved school, but my least favorite subject was math. Even today, I can't balance a checkbook.

"I won a history or English award, I forget which, in school one time that sent me to a contest which was held in Mount Pleasant. On the way there, I remember we saw the results of the Bath School explosion.[1] *It was terrible. Everything was flattened.*

"My mother was a widow at age 27. When Father died, she was left with three little girls. My father had a peddler wagon drawn by mules. He sold groceries and other goods from the wagon. As I understand it, my father died from the severe burns he received when his wagon tipped over with some sort of heater inside. The whole thing caught on fire.

"Thank goodness the house was paid for prior to my dad's death. Mother still had a hard time bringing us all up. My mother didn't re-marry after that. We didn't want her to.

"Mother was a very strong woman. She married at age 19, had me at 20, and was a widow with three girls to raise at age 27. She didn't work for a time, but then she got a job as a telephone operator. She was smart. She was the Hamilton township treasurer.

"I often think my mother was a very conscientious person. She had real values and she was religious.

"Obviously my mother was a major influence in my life but so were my grandparents on my father's side. I think they felt an obligation to take care of us. They were wonderful, just wonderful. Both of them helped me in the direction I was to go. I had an aunt, too, my father's sister, who was instrumental in helping to raise us."

Following a stint at business college, Gladys landed a job at Kalamazoo Vegetable Parchment (KVP), a paper mill.

"I worked there until I got married. That's where I first met my husband, Bert. He was the manager of the Dictaphone office in Kalamazoo and he made office calls to KVP in Parchment. We were married for 54 years before he passed away at the age of 80. He was always well, but he knew he had an aneurysm. It finally ruptured. They did operate, but it was not successful. He died three days after the operation.

"This was the worst period I have ever gone through. It was the first terrible thing that ever happened to us. It was hard on the kids, too. I didn't think my son was going to make it. It was awful.

"My kids and I got through it with our faith, definitely. Also, I saw my mother go through the death of my father and what her faith meant to her. That helped."

During World War II, Gladys's husband was

Kalamazoo's Bronson Park sported a McColl electric fountain, c. *1922. (Courtesy of the Rick Shields Historical collection.)*

on active duty for three years. While he was gone, Gladys worked once more at KVP.

"When he came home from the service, I quit work immediately. We bought a duplex, but after we had the children it was getting too small . We decided we had to move. My mother said, 'Do you suppose you could swing buying two houses?'

"Bert said, 'Oh, oh,' but then we began to think about it. I said, 'Well, why not? We'll just go ahead and do it.' And we did. It was the best decision we ever made because that house which we rented put our children through college. As my husband said, it was a gold mine.

"Right after he died I had to put a new furnace in and it was too much for me. I sold the house. I couldn't take care of it. You know, I didn't realize just how much work he did on that place until he was gone. He was really handy. He had us all spoiled."

Gladys believes that people her age can easily live in their own homes with reliable help.

"I have a cleaning woman, but I've always had one. She comes once every two weeks. I have friends and we eat out a lot. It seems the restaurants all serve such large portions, so I bring part of it home and eat it for the next meal. I rarely cook. I'm kind of tired of it.

"Also, I have the most wonderful handyman. He's worth everything and he does everything. I found him through a friend and now I've told others about him. I think he has four or five jobs for friends of mine. He does absolutely wonderful work. Everything in the house has gone wrong. I had the roof fixed but it is flat which causes many problems."

Gladys hopes to stay in her own home as long as possible. She gives her opinion regarding nursing homes.

"No matter how much I spend to keep this

65

A view of Bronson Park today. Abraham Lincoln once gave an address here, the only speech he ever delivered in the state of Michigan. (Lee Griffin photo.)

house up, it cannot be as expensive as it is to be in a nursing home. Anyway, I am too independent. Since I drive, I go where I please.

"Nursing homes bother me. I call on quite a few people who are in nursing homes and it disturbs me when I think they are neglected. Maybe, they aren't, I don't know. They look so lonely.

"My aunt was in one outside of town and I wouldn't want to go there. She had many friends there, though. I've been visiting when she didn't have enough chairs in her room to seat all her callers. I never heard her say she was lonesome. This is unusual. It's as if all these old people in there are waiting to die."

Gladys reflects on her healthy life and offers possible reasons for her longevity.

"I don't know why I am so well. I think it's God's gift to me. But, then, I think a lot of it has to do with attitude.

"Not long ago I saw a women I went to high school with. I couldn't believe she looked so old. Just an old, old, lady. I believe many of these older people put on these old shoes and old clothes and live the part.

"I hate those kinds of shoes and I don't buy my own clothes. My daughter buys them for me because she goes shopping. Anyway, I hate to shop."

She goes on to discuss exercise and various activities she currently participates in.

"I should have a regular exercise program, but I am afraid to walk around the neighborhood. The sidewalks are so bad here. But, you see, I do get exercise because this is a two-story house. I go up and down steps a hundred times a day.

"I also read a lot. I belong to a book group which meets every two weeks. We read

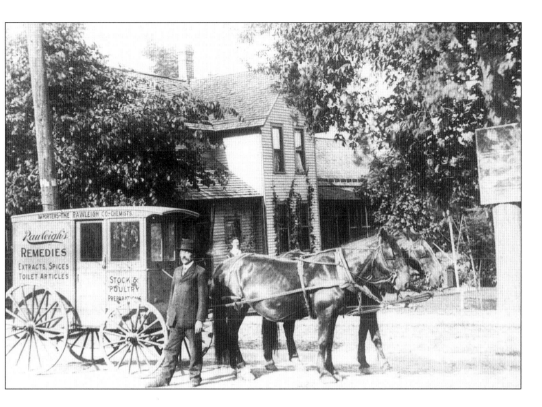

A peddler in early 1900 sells his wares door-to-door in Kalamazoo. (Photo courtesy of the Rick Shields Historical Collection.)

selected books and then meet to discuss them. At each meeting there is a video about the author. I like that very much."

In addition, Gladys enjoys staying home. She had done her share of traveling with her late husband and her children, she maintains. She has visited Europe several times, journeyed to Ireland, and spent one Christmas with her family in Spain.

"I love watching sports on TV. I enjoy golf, football, and basketball. I entertain some, too—have people in for dinner. I put sauerkraut in a crock pot and add some spareribs. I can do that.

"I also volunteer at a women's shelter in Kalamazoo. I've been there for 20 years. It's a nice setup. The house is a duplex. The house parents live on one side and the women live on the other side. They can take up to seven women, whose length of stay is about two weeks, more or less. Today, I'll go into the office and read the log to see what's up.

"The women are not supposed to be at the shelter until 3 p.m. because they are required to go out and look for jobs. They start at 9 a.m. Oh, they find jobs, but they aren't really good. Most of the jobs are at hotels or fast food places and they pay only a minimum wage.

"There is such a need for places like this. Just last week, I was so sorry to find the position this particular woman was in. She was a university student studying for an exam. She also had a class that evening, and here she is, pregnant. I feel so sorry for the baby as well as the mother.

"Hardly any of these unmarried mothers adopt their babies out. As long as I've been volunteering there has been only one. I wish I knew why. The change in morals is one reason. Unwed mothers and teen

Gladys and her husband, Bert, taken in Florida, c. 1987. (Courtesy of the Gladys X family collection.)

pregnancy—both are accepted by society, these days.

"Almost all of their kids are in foster care. There is one unmarried woman in the shelter, now, who has four children in foster care. I think she loves the children, but just can't take care of them.

"Another woman who was here just recently got her own apartment and has her children with her, but she is having a heck of a time managing financially."

Although not as active as she once was, Gladys is still a member off the Second Reformed Church. She contemplates the hereafter.

"I didn't know my dad because he passed away at a young age. That's why I want to go to heaven—to see him. Oh, yes. I believe in an afterlife. What would be the use of living if you didn't believe? There has to be more than just this life. I don't know what it is going to be like, but I do know it will be of

God and so it will be perfect. If I didn't think there was a life hereafter, I would have had a heck of a lot more fun. I would."

END NOTES

1. *In May of 1927, the Bath Consolidated Schools was dynamited by disgruntled school board member, Andrew Kehoe. The blast killed 45 persons, including 38 children.*

BOB PECKHAM

Bob Peckham retired from the Allegan School system after 36 years as a teacher and administrator, c. 1999. (Lee Griffin photo)

Bob Peckham lives with Eleanor, his wife of 62 years, in Allegan, a small city of 4,500 inhabitants located 30 miles from Kalamazoo. The town is situated on Lake Allegan, a body of water created by a dam on the Kalamazoo River. In the early 1800s steamboats plied the river, transporting lumber and farm crops to Lake Michigan for shipping elsewhere. Today, the town retains a small-town atmosphere and many of its homes exhibit a traditional appearance of turn-of-the-century style architecture.

Bob chalked up 36 years in the Allegan School District as both a teacher and principal. His last four years were spent as superintendent of schools. He retired in

Bob Peckham, who played several sports, including football for Kalamazoo Central High School, believes team participation and his coaches had a positive influence on his life. (Courtesy of the Peckham family collection.)

1976. I interview Bob upon the suggestion of his daughter, Betsie, whom I know from her work as secretary of the McKay Library board in the village of Augusta.

Bob, who is 81 years old, is one of six children. His father drove a team of horses and later worked as a truck driver hauling freight from Kalamazoo to Benton Harbor where it was loaded on a boat for a run to Chicago. The summer Bob finished the ninth grade his dad left the household. No one in the family ever saw him again.

"My mother had no means of support, so for several years it was pretty slim living. By the time I graduated from high school, I had lived in 15 different homes. I suspect we moved every time the rent came due. I don't know how my mother ever made it, because we had absolutely nothing."

During his formative years, the Great Depression was raging and times were tough everywhere, but Bob took little notice.

"Most of the kids I chummed around with were in the same situation. They didn't have anything, either. We never went hungry, though. Just how my mother managed, I'll never know.

"I had a grandfather who worked for Colonial Bakery in Kalamazoo. He was the one who took care of the horse stables, and frequently he would bring to the house big sacks of day-old baked goods which was pretty neat. To this day, I have a chum who remembers coming to our house and eating baked goods. Our menu was not greatly varied, but somehow we had food."

During this period, Bob also remembers having a filled tooth which was decayed so badly he didn't want to smile.

"I didn't want it to show and I remember taking cotton batten and stuffing it in there to conceal it. I went to a dentist in downtown Kalamazoo and he examined my mouth. His first question was, 'Who is going to pay for this?' I told him I didn't know and that terminated my visit to the dentist.

"Sometime after that, my sister was riding a friend's bicycle and she was hit by a car.

KALAMAZOO HIGH SCHOOL. KALAMAZOO. MICH.

689

Kalamazoo Central High School in the 1950s. (Courtesy of the Rick Shields Historical Collection.)

Some of the money resulting from the damage suit helped fill that tooth. I particularly remember that when I think of living on Cobb Avenue in Kalamazoo and all the things that went on there."

Having little money, Bob's primary source of entertainment during youth was attending an occasional movie at the new theater in town. It cost a dime.

"I remember how difficult it was to get a dime so we could go downtown to the new theater, the Orphium. I was frequently challenged with that 10¢ because I was tall and the cashier thought perhaps I was a little older and trying to sneak in for a cheaper price.

"Another interesting diversion of the evening was to shake the trolley off the line. It would stop and the motorman would have to get out, re-set the trolley, pull it down, and set it back down on the line."

The Be-Mo Potato Chip Company, located a few blocks from Bob's home, provided different type of excitement.

"Some of the fellows in the neighborhood, including me, discovered we could slip in there at night when the employees were in the back and snatch some bags of potato chips."

One activity Bob and his friends looked forward to every year was camping.

"I had two very close friends when I was in junior high and high school. Early in the year we began planning for a camping trip, just the three of us. We were so thoroughly absorbed and looked forward to it so much, that one time we hiked out from town to Bonnie Castle Lake near what used to be call Dougherty Corners.

Another time, we hiked way out to a lake near Bloomingdale where my mother's relative had some lake property. We went down by the railroad tracks and when a train went by, we threw all our stuff in an empty boxcar. Then he hopped on and got as far as Gobles (15 miles from Kalamazoo).

71

Bob Peckham and his wife Eleanor have been married for 62 years.

The train man came along and kicked us off. We had to hike the rest of the way."

In junior high school there were two teachers who had an impact on Bob's life. One teacher was the math instructor, Mrs. Baker, but he fails to remember the name of the other.

"Both of them said to me, 'Bobby, if you can maintain these grades you can go someplace.' Up to that time, I had no direction or influence from home to succeed at anything.

This is the first I can remember that anyone had said I had something, that I could go someplace."

In high school Bob's mentors were Kalamazoo Central basketball coaches Gene Thomas and Harold McKay. Thomas eventually became principal at Central.

"There were other coaches I was very fond of, but Thomas had as much influence on my life and the direction it took as anyone."

Bob graduated from Kalamazoo Central in 1936, and through his athletic and academic prowess was awarded a reagents scholarship to the University of Michigan in Ann Arbor.

"I didn't have enough money, even with a scholarship, to make it at the U of M, so I came back to Kalamazoo and enrolled at Western Michigan University (WMU), which was then called Western State Teachers College."

Bob had also received an athletic scholarship at WMU where he played varsity basketball for three years and was high point man the entire period. He was selected team captain in his senior year and upon his graduation in 1940, Bob received that institution's athletic scholarship award.

"My first job after college was teaching at Allegan High School in 1940. The first year I taught senior English, and World and U.S. History at Allegan High School. My salary was $1200."

He taught there for two years and then enlisted in the Army. United States was involved in World War II.

"Eleanor and I were married, but we had

no children. I knew I would eventually be drafted so I volunteered for a program titled Volunteer Officer Candidate. You go through all kinds of testing, finish basic training, and then are selected for officer candidate school. I was selected for chemical warfare and was commissioned in chemical warfare. Then, in 1943 I was assigned to the Air Force as a chemical officer. My duties were to advise the base commander. I was also responsible for the chemical warfare training of all the troops. I was alerted for overseas duty after VE Day, but the atomic bomb was dropped before I left the states and the order was canceled."

Subsequently, with active duty and time in the reserves, he logged 28 years of service and retired with the rank of lieutenant colonel. Following his discharge from active service, Bob went back to teaching. It was one of the most difficult choices he had to make.

"As a commissioned officer I had an occasion to talk with doctors and dentists. They often talked about their earnings in their professions. I compared what they were making with what I was making as a teacher with two years experience, and there was a dramatic difference. I made up my mind I was going to do something else other than teaching after I got out of service.

"I had a rude awakening. The first place I went to inquire about a job after I separated from the service, was the Upjohn Co. (a pharmaceutical firm now named Pharmacia) *in Kalamazoo. My major field was science, but I was told the only position available with my background was as a custodian. I decided to go back to teaching."*

Bob taught English and biology for a few years and eventually became junior high school principal, assistant superintendent , and superintendent of schools. He retired after serving the school system 36 years. During his tenure with the school, Bob acknowledges he has witnessed many changes.

"I am glad I'm not involved in the school today, because there are so many things I

The Kalamazoo River at Allegan. Note the iron trestle bridge—still in use today—which was built in 1886. (Lee Griffin photo.)

wouldn't be able to handle. I've thought about this on many occasions.

"In my time I always felt when we said, 'No,' it meant no. If there was any deviation from that, you took action right away. It doesn't seem this is possible today."

Bob cites one incident when he was principal of the junior high school. Two boys started fighting on the school lawn. One lad was the son of an eye doctor and the other was an attorney's son. Bob suspended both.

"The eye doctor said to me, 'Bob, I understand you suspended by son for fighting.' I confirmed that. Then he said, 'I'll make sure my son won't get a vacation while he is home.'

"The attorney's approach was, 'Did you see the fight? Did you see who started it?' He didn't think his son should be suspended and told me he wanted his boy back in school. I said, He is suspended.'

"This type of parent seems to be more prevalent, today. They want you to do everything for their children, but when it really comes to taking care of a problem, they don't want it that way."

In the 1950s, Bob relates teacher unions in Southwest Michigan were virtually non-existent except for a few schools in Detroit, and they were frowned upon as unprofessional. Today, teacher unions are commonplace in nearly every school district throughout the state.

"I was superintendent when I had to face negotiators for the teachers' union. I hated it with a passion. If it hadn't been for that, I wouldn't have retired when I did. I had one more year to go on my contract, but I didn't want to put up with it anymore.

"I hated negotiations with a vengeance because some of the damnedest people got on the union and approached me and tried to tell me what I had to do. I thought, this is wrong. As I look back, though, unions were among the best things ever to happen to teachers, but one of the worst things for the

profession.

"If I had sons or daughters today who were going to make a living and they asked me whether they should join a union, I would tell them by all means because you need that protection."

Bob believes that his participation athletics helped him become successful as well as giving him an opportunity to meet many different people.

"I mentioned to Eleanor the other day how thankful I was for being involved in athletics. In high school it was a big part of my life. As an athlete, I had to be very straight—no drinking or smoking, a model citizen. If it hadn't been for that, who knows in what direction I would have gone. At one time I was stealing pop and doing other things kids would probably get arrested for today."

Upon reflection, Bob speaks of his concerns regarding the state of the country and relates that the Vietnam War was bothersome.

"I was in the Reserves at the time, but that wasn't my concern. It was the constant disturbance of people in our country and the tremendous losses we were suffering over there that bothered me for a long time."

Former President Clinton's dalliance with a White House intern was very troublesome for Bob.

"These things have been going on for a long time. And maybe we are hearing about them more now than in the past. Either way, it is difficult for me to believe that a man like that could sit down with other world leaders and make any kind of favorable impression. In particular, he was trying to lead this country when so many people knew what he was and what he'd done. When the leader of the country sets as bad an example as you can find, how can you teach children right from wrong?"

Moreover, he's not certain whether such behavior among the nation's leaders will turn around.

"I try not to think about it because I'm not going to be involved in making changes. My

A 1934 record announcing an eighth grade commencement exercise to be held in the Central High School auditorium. (Courtesy of the Rick Shields Historical Collection.)

time is very short. I should hope things change for the better."

Although he attended the Methodist Church regularly as a youth, Bob notes at present he is not a believer.

"I'm not saying I don't believe in God, it's just that I don't know. Probably, a better term is agnostic. I have difficulty believing there is someone watching over us and directing us on a daily basis and determining our fate based on what we do and what we believe.

"I see so many children being killed in the street. If He is all powerful, why do these things happen? I've had this question for a long time.

"I have a doctor friend I play golf with regularly and he says the same thing. I was

surprised. He spent his whole life treating people. On the other hand, I know other doctors who have seen miracles and they believe. I just do not know."

Bob considers himself fortunate because thus far, he hasn't had serious health problems. Although he has diabetes, it is controlled through diet, exercise and maintaining a desirable weight. He remains physically active, fishing for big lunkers, and wading through the surf at his cottage in Northern Michigan.

"I still play a lot of golf and I also like walking for the exercise. I also read and have my computer. I have woodworking tools and machines in the basement I can use and I play bridge. Five or six of us usually play twice a week."

He continues to retain an interest in his community, and in the past has served on the hospital board of trustees, became president of the Rotary Club, was elected to the country club's board of directors and became a member of the community council, a group comprising area citizens trying to provide activities for children.

Not long ago, Bob was inducted into Allegan High School's Athletic Hall of Fame for coaching the varsity baseball, basketball, and reserve football teams, as well as his years working as an official for those three sports.

"One of the driving forces in my life for the past few years has been an attempt to be sure that Eleanor, if I pre-decease her, doesn't become dependent upon or a problem to any one of our two daughters, or has to go into a nursing home because of the lack of finances.

As I've said many times, we've been very fortunate. If one of us goes before the other, we will stay in our home and get outside help—that's the way we want it to go.

A view of the Allegan business center with a walkway along the Kalamazoo River, c. 2001. (Lee Griffin photo.)

MARJORIE VIOLA WILSON BRUNDAGE

Marge Brundage voluntarily fashions hundreds of hats for women who suffer hair loss from chemotherapy, c.1999. (Lee Griffin photo.)

Marge, as friends and acquaintances know her, lives in an apartment complex in the small town of Richland, 15 miles east of Kalamazoo. Her first husband died suddenly at the age of 42. She divorced her second spouse after being married to him for 15 years.

For more than three decades, I knew of Marge, but I never had the chance to meet her. I recognized her name through the activities of both our children.

One summer, during college days, I was hired by Richland village as summer assistant recreation supervisor. One of her sons, an energetic and mischievous eight-year-old, participated regularly in playground activities. Later on, Marge had the reputation of a mother who had her fingers into anything and everything that involved her children. She was a bundle of energy who took an active role in the PTA, Little League and 4-H, among others.

As our own children grew to adulthood and hers did likewise, her name would often appear in the newspaper for initiating or assisting in the formation of a new council or committee designed to help poor or disadvantaged citizens. So, it was with anticipation and pleasure that I sought to learn more about her life.

Marge was born in Cicero, Illinois, and is the eldest of two siblings. Her grandmother lived the family her entire life.

"I have very fond memories of Grandmother Giese. Grandfather died when I was three years old, but because my mother was an only child, my grandmother lived with us.

Periodically, she was a mother's helper whenever there was a new baby in the family or an illness. In every case she acted as an aide. She had a marvelous sense of humor and saw something funny in everything. She was very close to us all, and more compassionate, even, than my mother.

"I grew up in Riverside, a suburb west of Cicero. That's where I met my husband, Herb. I met him in church through the

young people's group. He was six years older than I was. At the time, I was 15 or 16 years old. He had been away to college and back. This was during the Depression so he didn't finish his education, either. Many of us started but couldn't finish, financially. I didn't.

"Our first date was likely a movie. I enjoyed movies and still do. So did he."

Marge graduated from high school in 1937. She and Herb were married two years later. The couple spent their honeymoon fishing and relaxing at a lodge in Northern Wisconsin.

"When I was first married I taught piano. I had gone to the Chicago Conservatory of Music. The woman I studied with created a branch of the Conservatory at Riverside. She employed me and I taught piano there until I started a family."

Subsequently, Marge and her family moved to Richland, Michigan. By that time she and her husband had four children, three sons and a daughter.

"That whole time I didn't work at all outside the home until my husband died very suddenly. My kids were 16, 14, 11 and 8 years old. He had one heart attack four days before Christmas. So then I had to go to school and learn how to make a living in order to take care of my kids. I went to Parsons Business College and learned shorthand and typing.

"Here I was with four kids and no money. I spent a large part of my life being scared. In that case, you either do what you have to, or you sit in a rocking chair and give up. Let someone else do it. That wasn't my way. I had to take care of them one way or another.

"The kids helped me get through it and what really helped was that I had to make certain decisions. Herb had a plumbing business. I had to do something with it.

"Everyone told me to hang onto it for my oldest son. I thought about it because he'd been working with his father every summer as a go-fer. After I thought about it, I decided no. If I do hang onto the business, the day might come when my son, then 14, would

An early photo of the IOOF (International Order of Odd Fellows) building and adjacent bank in the village of Richland. (Courtesy of the Richland Community Library's Local History Collection.)

say, 'Mom kept the business for me. Now I have to take it where I want to or not.'

"I decided right then that if he wanted a plumbing business, it had to be because he wanted it, not because I held on.

"I sold the business. Fortunately, the suppliers took the materials back and the new owner bought a few tools. Nevertheless, I didn't gain much, financially."

Meanwhile, Marge had landed her first job working as a private secretary to the chaplain of Bronson Hospital in Kalamazoo.

"There was no organization whatsoever for single people. Here I was, 36 years old and I didn't know anybody. How many 36-year-old widows do you know? Not many. Couples invite you to functions for a time, but then that fades away. I was just plain lonesome. At the same time, the Council of Churches in Kalamazoo was going to lose its director. As a result, Chaplain Trenery

encouraged me to apply for the opening. It would have been perfect because the job was for nine months a year. That meant I could be home with the kids in the summertime. Anyway, I applied for the job—the Director of the Council of Churches— and got it.

"There was no organization in or around Kalamazoo for single people. It was through my position with the Council of Churches that I developed a friendship with Dan Ryan, who was the former editor of the Kalamazoo Gazette. I had all this material about Parents Without Partners, and I said to him, 'Just read it and don't give me an answer, now.' He said, 'I'm not going to publish this. This is nothing but a lonely-hearts club. I told him, again, to just read the stuff and then call me. He called me three days later and said he read everything. 'When do you want to have a

Shown here at age 55, Marge Brundage played an important role in the development of the Comstock Community Center, c. 1974. (Courtesy of the Brundage family collection.)

meeting?' he asked. He put a nice article about it in the newspaper. The first meeting was held at a church in Kalamazoo.

"I had cookies, coffee, and punch, which I had planned for 36 to 40 people. Instead 88 men and women showed up. That was the first organization of it kind in Kalamazoo. Today, there are several. Just like Topsy it grew and grew.

"I always viewed the Council of Churches as an enabler for a purpose. For example, I worked with a fellow who was with the United Way. He and I formed a committee of people to get the Meals on Wheels program and Senior Services to merge. They had been separate entities, which were duplicating services and funds and everything else, so we got those two boards together. As a result Meals on Wheels came under Senior Services.

"I'm not taking credit for all this, but I did have some ideas as I saw the need and one of those needs was the availability of low income housing in the city of Kalamazoo. Called the Lift Foundation, this organization got churches, the Kalamazoo Gazette, *the Arts Council and others involved.*

"Many people on the north side of the city gave us houses for the tax breaks or sold them to us for nothing down on a long term land contract. We then took the property deeds to the banks and mortgaged them to the hilt. We did this to make the technical improvements such as adequate wiring, heating, and plumbing. Then we got a group of volunteers to perform the aesthetic work such as papering, painting, and landscaping."

Before long, Marge left her job with the Council of Churches to work with the director of the Lift Foundation. Later, she became its acting director, but after a year and a half on the job the chairman of the board asked her to come to his office. She was about to have a rude awakening.

"He said he decided that no woman could do the job. He asked me to go back to the office and train the man he had chosen. I said, 'You must be kidding.' His reply was, 'No, I want you to go back and teach him what you are doing now.' I asked for a sheet of paper. I wrote my resignation and told him it would take me five minutes to clean out my desk and I'd be gone.

"I'm a feminist from way back. If this had happened today, I would have sued his socks off. That mind-set has to change, but I'm not certain it can. I think it will take another generation before it does."

It wasn't long before the volunteer directors of the Comstock Community Center (Bill Courter, minister of the Methodist Church in Comstock and his wife) called Marge and asked whether she wanted a job. They told her the only problem was she had to raise her own money.

"The first thing I did was go to the director of the Kalamazoo Community Action

Program (CAP), which was part of President Johnson's poverty program. I told him what I wanted and how much I needed to open this terrible old building on the Kalamazoo River. It was awful, just awful.

"I got enough money and a crew together and we started the center. This was the only job I ever had where I needed to wear boots keep my feet warm from walking on the cold, bare concrete."

Marge worked with an architect who designed several plans. The Sisters of St. Joseph, owners of property along M-96 in Comstock, donated a chunk of land to be used for a building site.

"To finance the project, we had two millage proposals, both of which were defeated. I decided that we were going to have a community center, anyway, so I contacted our representative in Washington, Gary Brown, and asked if there was money available through the Housing and Urban Development program. We had previously worked together on some school board issues years before, so we were pretty good friends.

"Money was available through the Neighborhood Facilities Grant. Comstock Township was the only one in the state of Michigan which received the grant. The remainder went to Native American reservations."

Still, Marge had other hurdles to overcome. She had to prove need, so she approached a friend from Western Michigan University (WMU) and told him her dilemma.

"He said, 'We'll design a survey and get volunteers to go door to door to ask the questions.' That's what we did.

"Then we threw the results back to the computer at WMU and got the read-out. There was no question but what we qualified because of need, but it was a matching grant. Now, where do you raise $125 thousand for a building in an area of need?

"We started with a few fund-raisers and it didn't take long for me to figure out we weren't going to reach our goal this way. Some years past I had been on a committee

with Dorothy Dalton's (a philanthropist and member of the Upjohn family)[1] financial advisor, who was then the vice-president of the Upjohn Company. I invited him to go and take a look at the land and community center plans. Then I asked him if he thought Dorothy Dalton would be interested in this project. He said, 'Yes, I think so.' She gave us $125,000, which matched the grant from the Federal government.

"I filled out the grant, sent it in to Representative Brown with the assurance we had the money, and he got the grant for us. I called all the media for the first and only press conference I ever held in my life, and got Gary Brown on the phone from Washington. He confirmed the grant and that's how the Comstock Community Center came to be.

"After that, I worked myself to the bone, got sick, went back to help build the center,

The IOOF building is currently being utilized as a drug and sundries store, c. 2001. (Lee Griffin photo.)

Marge Brundage as she appeared at age 22. (Courtesy of the Brundage family collection.)

moved in and then retired two weeks later. That's my checkered career."

Marge makes a comparison in the attitudes of folks during her generation and that of her children and grandchildren.

"The way kids these days spend money absolutely boggles my mind, but it's none of my business and I don't make it so. There is simply a gap in understanding. My grandchildren think nothing of flying to Florida for New Year's Day to watch a football game. Then I think about what I lived on. When I had all those jobs, there was no such thing as a pension or a 401 K. There was nothing like that and pay was minimal.

"I even made soap during World War II. You took lye and rendered lard and boiled it down. The longer you kept it the harder it got. It made great laundry soap. You had to be careful how you spent those ration coupons. The cheapest meat you could buy was pork liver, which we cooked with vegetables and thickened with cornmeal. So you can see, my attitude toward a buck is downright

worshipful, almost, and the younger generation treats it like a passing commodity.

"I would say one of the biggest problems facing the nation today is self-discipline, both on an individual and national basis. It seems to me that common courtesy and care for one another has gone straight out of the window."

Among the activities which keep Marge busy and contented these days is exercise. She drives to Borgess Hospital's health and fitness center in Kalamazoo several times a week for warm water exercises. She also knits, reads books, and has an alterations business. She also wrote her memoirs and gave a booklet to each of her children and other relatives. It is through her alterations business that Marge became involved in the project of making hats for women who have hair loss from chemotherapy.

"One of my customers is a cancer survivor. She had a mastectomy several years ago and has a very expensive prosthesis. She purchases regular bras then brings them to me. I make a terry cloth pocket to hold the prosthesis. When she came to pick up some work I had finished for her, she spotted all these hats on my ironing board and asked about them. I told her I was going to deliver them to the cancer center in Kalamazoo when I finished a few more. She said she was on her way there and would take them in for me.

"At Christmastime, I bought scarlet red material and made bright, red hats with shiny brass buttons on them. I guess I've made more than 50 hats. I don't like to talk about it much. It's just my little contribution."

END NOTES

1. W.E. Upjohn, M.D., established the Upjohn Pill and Granule Company of Kalamazoo, Michigan in 1886. It later years it was known as the Upjohn Company until Pharmacia and Upjohn was formed in 1955. In 1999 Monsanto, along with Pharmacia and Upjohn created a new pharmaceutical company, the Pharmacia Corporation.

ROMAN AND CATHERINE JASIAK

Roman and Catherine Jasiak at their home in Lawton, c. 1999. (Lee Griffin photo.)

I have heard the details of Roman and Catherine's everyday life for several years because of my part time employment as a librarian at McKay Library in Augusta. Catherine's daughter is the director of the facility, and Roman's niece Mari is also a librarian.

My colleagues often talk about family gatherings, Roman and Catherine's dog, their new carpet purchase and other mundane subjects. When the couple make occasional visits to the library they are cheerful and outgoing. In 1999 we arrange for an interview.

I meet with the Jasiak's at their home, a white ranch located at the outskirts of Lawton (west of Kalamazoo), known for its grape production and its largest industry, the Welch

Roman spent two tours of service, one at age 19 and the other during World War II. (Courtesy of the Leamy-Mony family collection.)

Grape Juice Co. The couple is sitting around their kitchen table, finishing lunch. Suzy, their plump, strawberry blond Spitz dog goes ballistic, running, jumping, and twirling like a dervish. Catherine scoots him outdoors.

It is the second marriage for both. Catherine, now 84, had three children with her first husband. Her husband died at the age of 55 from cancer. Roman, who is two years younger then Catherine, married for the first time in 1941. Two years later his only child, a daughter, was born. His 21-year-old wife died of cancer while Roman was serving in the U.S. Army overseas. His daughter was one and a half years old at the time.

Roman: *"My mother and dad took care of her for a while and then she went over to her maternal grandparents who lived on a farm in Portage. She stayed there the entire time until I got back in 1945."*

The couple met each other at the wedding of Roman's niece, Mari, and Catherine's son, Larry.

Roman: *"That's how we got together. I thought I'd go out with her a few times and we did. We met in 1969 and got married a year later."*

Catherine: *"He had his house and I had mine. I lived on Charlotte Street in Kalamazoo. I bought the house from my mother and dad."*

Roman was born in Chicago, Illinois, and Catherine was born in Calumet, a town in the Upper Peninsula of Michigan. The two talk about their early years.

Roman: *"Two years after I was born, my mother and dad moved to Kalamazoo. That was 1919. My dad worked in a foundry as a molder. I suppose they moved for my dad to get a better job. He worked for the former Melbow and Wire Company, where Ingersoll's used to be located. I had two sisters and a brother."*

Catherine: *"My dad worked in the mines in Northern Michigan. He didn't like it at all. He always worked nights and slept days, I remember that.*

"I had two brothers and two sisters. I was eight years old when we came to Paw Paw

(west of Kalamazoo). My dad had friends there. They followed each other when there was the promise of a better job. He always wanted to get out of the mines, but my mother didn't want to come. She didn't like the idea of being a farm lady.

"In Paw Paw we had a 40-acre farm, but 27 acres were in grapes. Dad couldn't make a living on it right away so he worked nights in a packinghouse where baskets and crates were made.

"I don't remember very much about living up north except for the amount of snow we would get every year. People used to bank the houses with snow as a form of insulation. Can you imagine that? All the windows were covered with snow making it dark inside until spring."

For entertainment when he was a youngster Roman recalls imagining himself as a cowboy by taking a broom and pretending it was a galloping bronco.

Catherine: "We were lucky if we had a wagon to play with. When we got a little older, we went down to the neighbors who had one of those player pianos. Oh, we used to play that piano. That's how we learned to dance. Anywhere there was music we would dance."

After Roman graduated from Kalamazoo Central High School (class of 1935) where he played trumpet and tuba in the band, his first steady job was working as a golf caddy.

Roman: "When I was 18 or 19 years old I was an ambulance driver for the Civilian Conservation Corps (CCC)[1] at Fort Custer, near Augusta. I stayed there for almost six months and then enlisted in the Army where I worked in the medical department of the station hospital at Fort Sheridan, Illinois. At the end of my three-year hitch I got married and was drafted in 1943. A year later I was sent overseas."

Catherine: "I graduated from the eighth grade, but not from high school. I didn't want any more school. I wanted to work. First, I did housework for people and stayed

The Welch plant in Lawton indicates a major grape production region, noted for juices and Michigan wines. (Lee Griffin photo.)

Catherine and her first husband, William M. Leamy. (Courtesy of the Leamy-Mony family collection.)

in their homes. If I got $5 a week it was all clear, and I gave it all to my folks. You see, my room and board and food was furnished. My first big job was at a drugstore soda fountain. I was a soda jerk, and I made root beer floats and black cows as they called them. I thought I was really up in the world when I got that job. I was 16 or 17 years old. I loved it."

Their parents exerted the most influence in their lives, relate Roman and Catherine.

Roman: *"My mother, especially. When I was a kid, I used to run around with not too reputable kids and she cracked down on me. I can thank her for every licking I ever got. I hollered bloody murder and scrambled under the bed, but she went after me with a broom. It happened in the summertime and all the windows were open. Everybody heard."*

Catherine: *"Oh, my folks were so strict. I do think they were too strict, but maybe that's why we didn't dare do anything. This doesn't*

work with all children. Our parents didn't even let us kids go to the movies until we were 16 or 17. They never went to the movies themselves and didn't think we should go either."

Both spouses remember the Depression with each having a different perspective.

Roman: *"I remember it very well. I could make a nickel by running errands. Then I spent most of my time running all over town to find out where I could buy some meat at the cheapest price. Usually the meat was pork liver, which they used to throw away. Then they started charging two cents a pound for it or two pounds for a nickel.*

"My dad worked on the WPA for $6 a week and we got hand outs like bread and spaghetti without sauce. This was our meal. I know many times my mother went hungry so us kids would have something to eat. Kids today don't believe this. They ask why we didn't get food stamps. There was no such thing as food stamps back then."

Catherine: *"With me it was different because we lived on a farm. We had chickens, so we had meat once a week, on Sunday. We could have been worse off, but we didn't have much else during the week. Oatmeal, corn meal, and all those things I got so tired of, things you could get cheap and the most for your money. I don't know if the Depression caused me to save things or not. We didn't have anything to throw out. Even the potato peelings went to the hogs."*

The two have not always lived in Michigan. When Roman retired from his job with the U.S. Post Office, he and Catherine sold their home and moved to Florida.

Catherine: *"We thought if we didn't like it, we were coming back. We saw so many people down there who didn't come back— they were brought back. We didn't want to come back in a hearse."*

Roman: *"The first year we were in Florida, there were 20 deaths. Two women and 18 men who lived in our park. We made our friends there and enjoyed it. Just to have something to do, we worked part-time raking and cleaning up people's yards."*

Catherine: *"We lived in Bradenton for 19 years. We came back when my sister-in-law died of cancer. We were ready to come back, but it was hard to get used to the cold weather again."*

In retrospect, Catherine concedes that the hardest part about raising her children was not being able to get the things she wanted for them.

Catherine: *"I shouldn't have felt that way, but because I had so little, I didn't want my kids to go through what I did. It didn't hurt them, though. What you don't have, you don't miss.*

"We had so little when we were young. If we got a banana or an orange for Christmas it was a treat. "

Roman: *"For me, the hardest part about raising my child was not being able to use the telephone. I guess this is still true. My daughter would come home from school with her girl friend. When the friend left, not more than five minutes would go by before my daughter would be calling her. I used to hate that."*

Catherine: *"We didn't have a telephone so I didn't have that problem."*

The pair speculate as to what they would do differently if they could re-live the past.

Catherine: *"Not having any more than I did, I probably couldn't have done a thing differently. I did the best with what we had. My first hubby brought home $27 a week. I had to figure out how to pay on our house, car, food and whatever else crept up. We took insurance out on our kids when they were born for 25¢ a week. The insurance man came around once a month to collect.*

"I'm spoiling my kids now because I wasn't able to when they were young and I think to this very day that I so much appreciate the things I buy (for myself) because I went so long without."

Roman: *"We probably should have traveled more because now it's getting rougher for me to drive. There have been so many plane crashes, that has kind of discouraged me.*

"Catherine probably would have liked to learn to drive. It's too late, now."

Roman Jasiak was a senior at Kalamazoo Central High School when this photo was taken. (Courtesy of the Leamy-Mony family collection.)

Catherine: *"The children couldn't wait to get behind the wheel, so I let them. I was tickled they wanted to learn. I didn't see the need for myself. I was close to where I worked. As you get older, you think maybe you didn't do the right thing."*

The two, who are Catholic, note that their religion is very important to them and credits it for helping them through hard times.

Roman: *"Sometimes you think nothing helps, but it does. We believe in life after death, heaven, hell, and purgatory."*

Catherine: *"If you don't believe, there is nothing for you. Religion also holds you from doing things you shouldn't."*

Roman: *"Our belief is no matter what, after you pass away, you either see God or*

The old stone railroad station in Lawton now serves as a VFW Post, c. 2001. (Lee Griffin photo.)

are with Him. If not, you are going down below to see someone else.

"We believe in purgatory, which means that the sins you have committed are forgiven. You have to pay for those sins by remaining separate from God until you are clear. We also believe that if you do something for God when you die, you will go straight to heaven like the saints.

The Jasiaks bring to mind their most frightening experiences. For Catherine, who was 12 years old at the time, the incident occurred when she and her sister were walking home from church.

Catherine: *"Two fellows wanted to pick us up in their car. That was very unusual in those days. Well, we ran to the closest neighbor's house. The other homes were a half-mile apart. These particular neighbors lived in an old, beat-up boxcar from the railroad company. We didn't know them well, but that didn't mean anything to us because we were so scared. They took us in for a while and then we headed out. We made it home all right."*

Roman: *"The scariest time for me was at the end of World War II. I was in the Signal Corps in Okinawa. The troops were celebrating the Japanese surrender after we dropped the atomic bomb. I never saw a more brilliant display of fireworks in all my life. Everyone was shooting off machine guns, pistols, skyrockets, and cannons. We had to dive into our foxholes in case a stray bullet got us. Actually, more than eight guys got killed that night. That was the closest I've ever been to combat."*

Catherine: *"I wonder if all that noise and shooting didn't have something to do with the fact that, this year, you are having trouble with your hearing."*

Roman: *"No. That was over 50 years ago. The end of the war was scary in another way. From the beach I saw more than 20 graves. The cemetery was full. War always takes the cream of the crop. It's a shame."*

END NOTES

1. *The Civilian Conservation Corps*

N. Lorraine Beebe

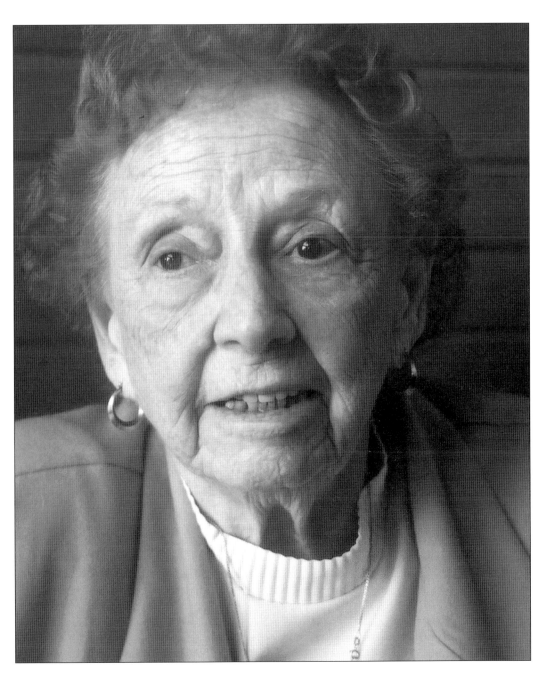

N. Lorraine Beebe, a former state senator, recently received the Irving S. Gilmore Lifetime Achievement Award in Kalamazoo, c. 2000. (Lee Griffin photo.)

I telephone Lorraine many times to set up an interview, but all I get is a recording with a promise to call back. Several weeks go by and I hear nothing. I figure Lorraine doesn't want to talk so I mentally cross her off my list of persons to question. After all, she and I have never met and we have no mutual friends or acquaintances. I know nothing of her background except that years ago she served briefly in the Michigan legislature.

One day she calls with an apology and says she's been very busy assisting a woman candidate who is running for election to the Michigan Senate.

Subsequently, we meet at her brown, A-frame home, located in Portage, now a burgeoning city which was once part of Kalamazoo. We talk in her comfortable second-story living room, which overlooks a large lake, now absent of activity. It is September and majestic trees color the landscape with their crimson, yellow, and burnt orange leaves. A pair of swans bobbing for food is seen from her picture window. Her white and brown dog Maggie lies at her side.

She greets me with pleasant formality, which disappears as she becomes caught up in ideas and conversation. At the end of four hours, I've realized I've shared time with a remarkable woman, a mother of two children, a grandmother and a former state senator, who has spent a lifetime of advocacy for the less fortunate, ensuring the rights of women and children, the developmentally disabled, and Native Americans, among others. She is the recipient of numerous accolades for her lifetime of service to others, among which includes awards from the Michigan Education Association, The President's Committee on Mental Retardation, outstanding citizen honors from Michigan State University and the Woman of Achievement Award from the Kalamazoo YWCA. In addition, she's been selected for membership in the Michigan Women's Hall of Fame and most recently received the Irving S. Gilmore Lifetime Achievement Award, sponsored by the Volunteer Center of Greater Kalamazoo and the *Kalamazoo Gazette*. Both the national and Southwest Michigan Planned Parenthood organizations have also honored her for fostering reproductive freedom for women.

Ninety-year-old N. Lorraine Beebe (she won't reveal her first name) was born in a house located on East Walnut Street in Kalamazoo. It was built by her paternal great-grandfather who was from the Netherlands.

"Ethnically, the neighborhood was diverse, with Dutch, Jewish, English, and German families living there. In our area, circuses and carnivals used to come in on Portage Street. My grandfather had a big barn and I used to sit out in back and watch the carnival workers do their jobs. I remember the women did all the work. That made a big impression on me.

"The neighborhood also had a bordello two houses down from us. This was in 1917 or 1918. I was fascinated by these beautiful young ladies.

"My mother would always tell me to stay in our own yard, but I didn't. I was always a very curious child and wanted to know what was around the next corner.

"The girls were all dressed so prettily and nice and they would always talk to me. The madam's name was Mrs. Kennedy. She always had a cookie for me. Mother was incensed, but I always got my cookies. That's the kind of person I was and still am. I wanted to learn about a situation, why it happened, and if it could be helped, what could I do?"

Lorraine's first encounter with racism occurred when she was in junior high school and was a member of the field ball team. Several team members were African Americans.

"We were beating everybody. Then I got a call from the gym teacher. She told me that we couldn't have the African Americans on the team, anymore. 'Why,' I asked. People were complaining, I was told. I said, 'Nuts.'

"You see, blacks worked for my father and grandfather in their coal and seed business,

and I had these school associations. Then the principal talked to me and said he was sorry, but he had to follow through with it. There were all those people who had a lot of influence at the time—they still do—and I said, "Well, then, we won't play at all." We were beating everyone. We were number one in the city. As it turned out, the principal backed down and told us to go ahead and play. We won again. Something like this makes such an impression on you and you never forget it."

Lorraine graduated from Kalamazoo Central High school and wanted to attend college but her parents didn't have the money. She mentioned her plight to a high school friend, whose father had a high position in what was then the Upjohn Company, a pharmaceutical firm. He found her a part time job and she financed her college education by working on Saturdays and over summer breaks.

Lorraine graduated from Western Michigan University with a teaching degree in physical education. Since no teaching jobs were immediately available, she continued to work at Upjohn in the bookkeeping department. Then she landed a job teaching swimming at Lincoln and Kalamazoo Central. Then she was hired to teach swimming and calisthethic classes in the evenings with the city recreation department. Eventually she earned a master's degree in psychology from Wayne State University.

"Another woman who was hired to head the woman's recreation program apparently didn't work out, so the head, Pete Moser, asked me if I would be interested in the job. I told him no, I was happy teaching where I was. Later, I got a call from Ethyl Rockwell, one of the first women to head the physical education department in the Kalamazoo Schools. She asked me why I turned down the job. I explained that I loved what I was doing, I was saving money and I was planning to buy a car. She said all those things are fine but that I had the skills to do more with my life. She went on to talk to me about the role of woman, which

This Kirk Newman sculpture "Children at Play," is a prominent feature in Kalamazoo's Bronson Park, c. 2001. (Lee Griffin photo.)

was just on the horizon. She said women are going to be expected to take a leadership role and they should be ready to do it. She wanted me to reconsider and to take the job.

"As I look back, the vision that woman had was fantastic. She let me know that I had the skill and potential to take my place in society. I knew she was right, so I ended up taking that recreation job. This was a big turning point in my life."

One of the first problems confronting Lorraine in her new job was to find a solution to the warring factions in the women's choir.

"I looked at those women and I thought, this is silly, all this fighting. They had beautiful voices and they had done so much

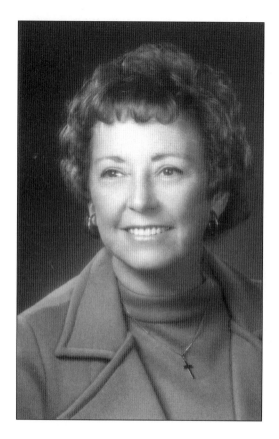

At the time this photo was taken in 1966, Lorraine Beebe was the only woman serving in the Michigan state senate. (Courtesy of the Beebe family collection.)

together. I picked out two or three choir members and asked them to explain the problems. After a couple of meetings we had everything resolved. This taught me something important—that you can negotiate, which I had never done before in my life."

After two years with Kalamazoo City Recreation Department, Lorraine was hired as women's recreation director in Dearborn.

"I learned so much in Dearborn because this was a time when families were coming from all over Europe to work for the Ford Motor Company. There were all these nationalities with very few who could speak English.

"To help the women and children become

adjusted to living in America and because their men were working long hours, we established the girl's club and other programs for them. It broke my heart at times to see how lonely they were.

"I also observed that men were going down south and marrying young women, actually girls, and bringing them back here where they started families. We were doing total programs, with night classes in English and other subjects in addition to recreational activities. We wound up with that place becoming alive with all kinds of women and children talking together and getting involved.

"As I look back, I realize I have had great opportunities to help people and on each occasion it was like a door opening."

However, the opportunity to help others less fortunate than herself would come later when Lorraine entered politics. Meanwhile, she married a University of Michigan athlete. He had worked in one of her summer recreation programs.

"He was a good baseball player, a catcher. He was picked up by the Boston Red Sox and went to Malone, New York."

She left her job in Dearborn to follow her husband. Later, they returned when her husband was hired to work at the Ford Motor Company. During the course of his job, Lorraine traveled frequently with her husband to Europe and Asia. Those journeys provided her with many opportunities to view poverty and its effect on women and children.

In 1964, the mayor of Dearborn asked Lorraine, then a Republican, to run for the Michigan State Senate in Lansing.

"I said forget it, but my son, Peter, and his friends got the nominating petitions signed anyway. Well, I ran and lost by 300 votes. I had it."

In 1966 she was asked to run again. This time she won the legislative seat for Dearborn by 800 votes, beating a strong Democratic incumbent. At the time she was the only woman serving in the state Senate and the third woman in the state's history to

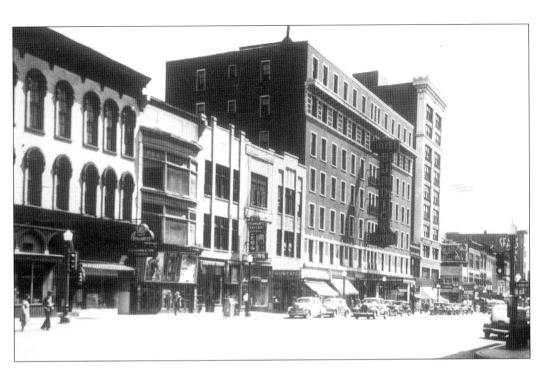

A view of Main Street in Kalamazoo during the 1900s. (Courtesy of the Rick Shields Historical Collection.)

do so. Since women in politics were something of an anomaly, Lorraine faced a few challenges in her new job.

"Oh, the men were nice to me, but they didn't think I would do anything. For instance, the first caucus I attended, they gave me a notebook and a pencil for taking notes. This is a woman's role, you see. It happened two or three times and I resented it. Also when the men would talk about a piece of legislation, I would offer a few ideas which they said wouldn't work.

No one came right out and said this, but one of the men would come up with the same idea, addressed differently. I was enough of an individualistic person that I didn't want to take it anymore. The next time I went in for a caucus, I said, 'Well, whose turn is it now?' and I laid the notebook on the table. No one asked me to take notes again.

"They didn't want a woman at first, because they thought I'd put on my hat and gloves and go shopping.

"However, I didn't live up to their expectations. I got into the action. They realized I was serious about the job I was doing and that I wasn't afraid of getting into hot water."

As the lone woman in the Senate, there were no toilet facilities in the chamber for women. There was a restroom for the several women serving in the House of Representatives.

"The majority leader approached the Speaker of the House who asked the women if I could get a key to their facility and they said, "No." When I came out of one session in which I was trying to get a key, I didn't realize several press people were standing around. Someone asked me if I got a key to the john. I told them no and was then asked what I planned to do.

I said, 'You know, I think I'm going to get a port-a john and I think I'm going to put it here in the lobby and then, maybe, someone

will do something.' Believe it or not, the story hit the press.

"Later, I was called to a caucus meeting where there was a box on the table. My colleagues said, 'This is for you, Senator.' Inside the box was an antique potty-chair. I just roared. Then they handed me a key to the rest room. I never used it. You talk about resentment. Well, I felt it more from the women in the House than I did from some of the men. You see, I was getting involved in issues that were controversial, but I felt I had a responsibility to women, not only in my district but to the women of Michigan."

Lorraine sponsored legislation allowing sex education to be taught in the schools, pushed for gun control laws, fought for improving living quarters for female prison inmates, and worked on alternative education for pregnant girls and advocated for placing tough drunken-driving laws on the books.

In 1970, Lorraine lost her bid for re-election, which she attributes in large part to her strong support of abortion rights.

"I'm not for abortion. It should simply be up to the individual for extenuating circumstances such as rape, incest or in the case of severely deformed child.

"I was disappointed and sad when I was defeated, but on the other hand, another door opened and I took advantage of the experiences I had."

She served for two years in the states Youth Services Department as well as the executive director of the Michigan Consumers Council. In addition, President Nixon appointed her to the President's Committee on Mental Retardation, of which she served for nine years. During that time she became vice chair of the committee and traveled all over the world and nation promoting more support and programs for the mentally disabled.

"God created all of us to be something, even those who are handicapped or those who may not be too bright. Some of the most loving people I've met are mentally or severely retarded."

In 1977, Lorraine moved to Portage where she remains active in politics and community affairs. She supports Planned Parenthood of South Central Michigan, served on the Portage Planning Commission for a number of years, and was on the board of directory for the Portage Community Outreach Center. Currently she is program chair for that group.

"We take care of those in need. People come in for food and clothing, for example. We also have tutoring programs for school children. We also have educational programs, such as the session we had on women and AIDS. We had a fantastic turnout."

She also remains active in the League of Women Voters and St. Barnabas Episcopal Church in Portage where she served as senior warden three times and is currently chair of the Christian Education Committee. Until recently, Lorraine admits to fibbing about her age, oftentimes lopping off 10 years. After her 28 year marriage dissolved, she believed her action was necessary.

"I had to find a job. Most of my friends were getting ready for retirement, but I couldn't. I had a daughter in high school and a son at the university. There was still a mortgage on the house. I had to have a job, so I just knocked more years off my age.

"I firmly believe we need to change attitudes about people growing older. For instance, when you say you are 80-something, people think you'll be around awhile. If you reveal that you are 90, people think you are old, that you are not all there and not capable of accomplishments.

WESLEY RAY BURRELL

Wes Burrell was principal of Galesburg-Augusta High School for 16 years, the longest tenure in the school's history. He is shown here in his library comprising over three thousand books, c. 1999. (Lee Griffin photo)

In his hometown of Galesburg and the nearby village of Augusta, 85-year-old Wes Burrell is regarded with affection and the upmost respect. He and his wife, Ruth, were long time school teachers in the Galesburg-Augusta Schools. She taught elementary and high school physical education, and he served as a teacher in English, social studies, and history.

Later, his wife headed the school libraries and Wes became high school principal, a position he held for 16 years. It was the longest tenure in the school's history, which endures to this day. He often pays visits to various schools in the district where he presents slide-show talks on various trips he and his wife took throughout Europe, the West Indies, and elsewhere.

The couple, who had no children, celebrated 57 years of marriage when Ruth had a stroke and passed away. Today, Wes lives in his 12-room, Victorian Italianate home. I interviewed him in his personal library which contains over 3,000 books reflecting his interests: poetry, history, classic literature, reference books, and natural science, among others. In the library are large photos of his wife, as is the case in every room of the house. He often speaks of her in the present tense.

Wes was born in Denton, a small town located near Detroit. A short time later, he moved with his family to Ypsilanti and attended Roosevelt, a laboratory school run in conjunction with Eastern Michigan University, then called Michigan State Normal College.

"The philosophy of the State Board of Education in those days was to provide a laboratory school which was the primary training ground of teachers. It was kind of a semi-private school and there was tuition. Parents had to put their child's name on the enrollment list the time the child was born, because the class size was limited to 28. When it was filled up they would turn people away. They would have to attend public school. Everyone thought the lab school was better because it has such highly trained teachers. A few college professors even came in to teach classes. The lab school philosophy was done away with in 1953 or 1954."

After he graduated from high school, Wes attended Eastern Michigan University. The student population was 3,000 students. Today, 24,000 students are enrolled.

While at Eastern, he signed up with the National Guard. His pay was $1 for every meeting he attended.

"A dollar during the Depression was quite a bit of money. I had to attend three-hour meetings on Monday nights, and we would drill and learn first aid. I eventually became Staff Sergeant and finished my term in 1937. I still had another year to attend college.

"Admittedly, your dollar went a lot farther because gasoline was 10¢ a gallon and food was cheap. I lived at home which was only five blocks from campus, so I walked to school.

"When I graduated in 1938, I couldn't get a job. This was still the Depression and if people had jobs, they hung onto them. I interviewed with half a dozen superintendents to no avail. They kept saying they wanted someone with experience. In exasperation I asked one superintendent how I was going to get experience unless someone took a chance on me. Well, he laughed and said he understood my predicament. With each vacancy, he explained, he received 30 to 40 applicants, and most of those had 10 years of experience.

"I finally found a job mixing cement by hand for 25¢ an hour. That was the going price for unskilled labor—about $2 a day.

"When I graduated, I thought, here I am with a degree in English and have no job. I was still mixing cement like a common laborer, but I did manage to do a little substitute teaching on occasion."

In the spring of 1939, Wes was interviewed by a superintendent at Hastings High School. He needed a remedial reading teacher. Wes's major was in English and he lacked one class

This is a view of the Kalamazoo River as seen from 35th Street in Galesburg, c. 2001. (Lee Griffin photo.)

which would have given him another major in speech. He had a minor in history and had completed several courses in geography, but Wes had no classes in remedial reading.

"The superintendent told me he was going to the University of Michigan in Ann Arbor to see what teaching prospects he could find there and I thought, oh, well, that ends that. He said, 'You may hear from me.' Well, I heard that before, but by gosh, in four or five days, I got a telephone call. He said if I were still interested in the job to come on up and bring my suitcase."

Wes landed the job, but it was only for the balance of the year. The teacher he replaced had taken a medical leave. The superintendent told Wes if his work proved satisfactory and if a position opened up at the end of the year, he would be considered first for the job. As it turned out, Wes replaced a teacher who left to attend Yale to work on a Ph.D. degree.

That summer Wes got the chance to visit England with the head of the English department at Eastern Michigan University

"I became very good friends with Dr. Gerald Sanders. I was one of his fair-haired boys. He took a liking to me and I used to go to his home in the evenings and drool over his library. He had a wonderful library. Now I have one. I used to look at all these wonderful poetry books and one day in the spring when I was mixing cement, he said he was going to England to work on Lord Tennyson[1], and asked me if I wanted to go along. His wife wasn't going because they were building a new house and she wanted to be there with the architects. I told him I didn't have a job and he said it wouldn't cost much. I told him I didn't have any money, that I was working for $2 a day. Then, a few week later I got this teaching job

Wes Burrell at age 38, c.1953. He and his wife were co-sponsors of the Galesburg-Augusta High School seniors in that year. (Courtesy of the Burrell family collection.)

in Hastings. They signed me for $1400 a year, and I almost fell out of my chair because most schools were going for $1200. I thought I died and gone to heaven. I never had so much money."

So Wes and his friend went to England in May. Wes joined the youth hostel, bought a new, three-speed bike and cycled 973 miles throughout the country.

"I went to all the literary shrines. My friend and I went to Summersby where Lord Tennyson's father was a rector in the church. He had permission to go up and talk to those people. He met Charles Tennyson who was the old man's grandson. The grandson gave my friend permission to read Lord Tennyson's correspondence. It was locked up in a bank vault in London. Every day while we were in London, my

friend would go down to the vault. They would leave him in the basement locked up because this was rare stuff. He would spend all day down there trying to read the terrible handwriting."

It was during his first year of teaching in Hastings that Wes met his future wife, Ruth. She was teaching physical education at Hastings High School as well.

"Ruth had been there for two years when I came. She also had charge of the library and was working on her master's degree at the University of Michigan. We were married in 1940."

Within three years, World War II was underway and Wes was drafted. He served in France, Germany, and the Philippines. Meanwhile, his wife completed her master's degree at the University of Michigan in counseling and guidance. She also worked at the Kalamazoo Public Library and the Hastings Library.

"The Hastings library was a combination public and high school library. It was open to the public and kept open on Saturdays. During the war, Ruth worked there quite a while. After I came back, I taught for a year or two, then both Ruth and I resigned, sold our home, and went down to the University of Michigan and I finished up my master's degree (in English) in 1948."

Over the years, the two taught in various school systems. At one time, Wes was teaching English and social studies at Galesburg High School while his wife was teaching in Kalamazoo, approximately 15 miles away. At work, Wes hear rumors that the current principal was not going to receive a new contract for the following year. Later, the superintendent offered Wes the job.

"I told him my master's degree was in English, not administration, but he said it made no difference. In those days, it didn't. The school was accredited by the University of Michigan and they didn't require the principal to have a master's degree in administration.

"I said, 'Well, I'm happy teaching English

and social studies, and I really don't think I want to be principal.'"

The superintendent repeated the job offer and sweetened the deal by suggesting that Wes's wife be hired to organize a girls physical education program for students from kindergarten through 12th grade.

"Well, that was different, so I talked with Ruth and she said, 'Why don't we do it? We'll be together and if we don't like it, we'll quit at the end of the year.' So I gave my okay and I was principal for 16 years, the longest tenure of any principal before or since."

His wife continued to teach physical education for five more years and later organized the library at the high school as well as developing libraries in two elementary schools within the school district.

"They gave me a new contract for the 1965–66 school year with a raise, but I finally said to Ruth, 'What would you say if I resigned my job and went back to teaching?' I told her I had just finished making out the schedule for the new year and we had to add two teachers. One was a history teacher and I was anxious to start a geography class which I was trained to teach. She said it was fine with her and it would give us more time at home.

"I told the superintendent I enjoyed teaching and would just like to be relieved of administrative headaches. Although I truly did enjoy my job as principal 90 percent of the time, I wish I was back mixing cement the remaining 10 percent."

Throughout their marriage, the couple traveled extensively. They visited England 12 times, vacationed in Spain, Italy, Greece, Belgium, Monte Carlo, and Morocco. They always toured England by car.

"I have hundreds of hours of tapes. I dictated as I was driving through Europe. I hadn't heard them in 30 years. Ruth's voice sounds like she is right here in the room. I've had so much fun listening to these. They also tell how much we paid for the antiques we bought all over the countryside and where we bought them. Ruth collected cranberry

This monument of General William Rufus Shafter, born in Galesburg, occupies a prominent place in town. Shafter headed the Cuban Expeditionary forces during the Spanish-American War, c. 2001. (Lee Griffin photo.)

glass and I collected copper luster. We also collected English character mugs.

"Throughout our travels we met several well known people. We had an apartment at St. Martin and Benny Goodman had a home in Oyster Bay. The beach there was not very good. We lived on Great Bay and it had a wonderful beach for swimming. Benny would come down and swim at our beach. Eventually we got on a first name basis and I used to swim with him.

"Ruth knew Johnny Weissmuller.[2] *He visited Western Michigan University while she was a student. He came and put on a demonstration. She swam with him in the pool along with some other girls. This was*

99

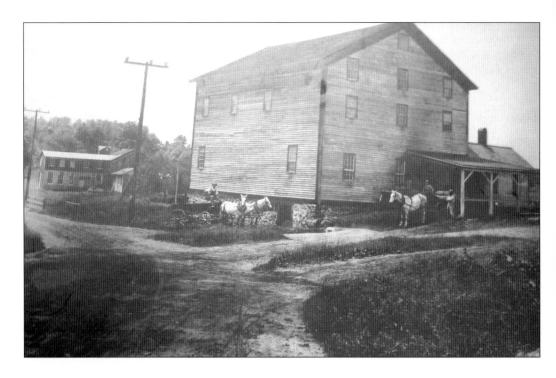

The ghost town of Hollandsburg, near Galesburg, had a grain and cider mill in the late 1800s. (Courtesy of the Augusta McKay Library Historical Collection.)

around 1933."

Pondering the most important invention during his lifetime, Wes finds it difficult to settle on one, and suggests several.

"The first invention I can think of that probably influenced more people than the telephone and telegraph was the automobile. Instead of building a luxury car for the rich, Henry Ford concentrated on making the car for everyone. As a result, roads became paved and suddenly people were liberated to travel all over the U.S.

"The airplane was another important invention. We are now able to go all over the world in a matter of hours. In the old days, it would take weeks, sometimes.

"Now comes the computer which has really changed our lives. More and more people are getting them and they are becoming more and more popular. Every business is run by computer, these days. Anytime you visit the doctor or go shopping, your name, address, and everything else

about you is on the computer. Because of this, we have lost much of our privacy. Everybody knows your business".

Wes comments on what he believes are problems facing the nation today.

"Moral decay of our whole culture is one. This is pointed up by this Clinton and Monica thing, but it was long before that. Also, the lack of manners is a problem. This disturbs me. Somebody suggested there should be a class taught in high school on manners. I agree, because you hear so much these days about different kinds rage and that's only one aspect of it.

"In my day, I was taught to say please and thank you and to be mannerly and use good language. Now, I'm not a prude. I've spent six years in the Army and I've heard every obscenity there ever was, but it disturbs me to hear it in the movies and hear women using language I wouldn't even use."

Although Wes grew up as a Methodist, he

This is a photograph of the Hollandsburg School. (Courtesy of the Augusta McKay Library Historical Collection.)

doesn't belong to a church. He explains his reasons and comments on religion in general.

"As a kid, along with my family we went to Sunday School and church regularly. Later, in Hastings, where I had my first teaching job, I joined the choir at the Presbyterian Church. After Ruth and I were married (she was brought up as Methodist, too) she joined the choir, also. After the minister invited us to join the church, we became members. When we left and came to Galesburg to teach we went to church one time and didn't like it at all.

"The minister spent the entire 25 minutes railing against the evils of drinking and if you took a drink you were going to Hell for sure...that sort of thing. Well, that turned me off. I drink a little wine and I don't think it's evil or is a sin. We started going to the Congregational Church and we've been going there ever since.

"I told the minister of the Congregational Church that I didn't want to join because I'm not interested in church work. I don't want to get on any committees. I've had enough of them to suit me the rest of my life. I'll support the church, though.

"There is a mysterious power. Some call him God, Allah, or Jehovah. I don't think it makes much difference what ritual or dogma you follow because I believe we are all going to the same place. A good analogy was given by a friend who said he looked at it this way: you get on the streetcar (that dates me) at Fourth Street and I get on at State Street, and we are both going to get off at the same place downtown.

"I'm putting all my trust in the fact that there is an afterlife. I certainly hope and pray there is because I miss Ruth terribly. We were together constantly at work, and that's unusual for most people. We worked together and spent all our spare time together."

Over the years, Wes has had numerous

Augusta's wooden basket handle factory in 1976, the only such facility known to exist in the U.S. (Lee Griffin photo.)

hobbies and belonged to various organizations. He collected single-shot rifles and found obsolete cartridges and molding tools for them. He also garnered more than 150 gun books, many of which came from England. He sold his collection of books and guns when he and his wife retired.

These days, Wes stays busy with his woodworking projects. He has finished more than 100 items of furniture, from simple end tables to a handsome high boy chest, with hand-carved legs and drawer pulls. He gives many of his creations to family members and friends. When he's not in his workshop, it's a good bet he'll be writing.

"I love to write. I wrote a book on the portrait of a marriage (ours). I had five copies printed and bound and gave them to our double nieces.

"I also have a genealogy on the Burrell family when they came from England in *1837, and I still do genealogical work on the computer. I'm trying to write a series of sketches on as many of the Burrell family members as I can."*

END NOTES

1. *Lord Alfred Tennyson (1809-92) was thought to be England's greatest poet. In 1833 he published a volume of poems which included his famous* The Lotus-Eaters *and* The Lady of Shalott. *He was named poet laureate in 1850. He died in 1992, and is buried in the Poets' Corner of Westminister Abbey.*

2. *Johnny Weissmuller was an actor/swimmer who won five Olympic gold metals in 1924–28 for swimming, with 67 world and 52 national titles. As an actor he appeared in many Tarzan and Jungle Jim movies.*

Dorothy Hill and her great-granddaughter, Kelsey Meints, c. 1998. (Lee Griffin photo.)

Ninety-one-year-old Dorothy is a neighbor. At various times I hear bits and pieces of her early years, but never the full story. I learn her family had been poor and she had led a hard life, but she is reticent to talk about it. She argues that what has happened is now in the past, and questions whether those experiences will serve a useful purpose.

However, after several unsuccessful attempts to interview her, Dorothy finally agrees to sit down with me and talk on a warm, summer day in 1999.

Her small, log-cabin type home is located in a 19-acre tract of woods bisecting Gull and Sherman Lakes near Augusta. We sit in her knotty pine paneled living room—she in a chair and I on the couch. Next to her chair is a floor lamp and an organ, which she plays daily. At the opposite end of the room is a massive, dark brown upright piano. Its ivory keys are aged yellow. A large print Bible and a large, thick magnifying glass lie on a small table adjacent to her chair.

Cataracts have clouded her vision. She wears glasses and also uses the magnifying glass to see what she is reading. Hearing aids are visible in both ears.

Hanging on the walls are colorful hooked rugs, one of which depicts a cactus in the desert at sunset. Its colors are rich reds, oranges, and blacks. She admits she fashioned the wall hangings before her eyesight diminished.

By the time we end our meeting, I am impressed again with my mother's inner strength and abiding faith.

"I was born in 1908, in the southwest part of Oklahoma. Previously Oklahoma was an Indian Territory and became a state in 1907. That was the same year Mother and Dad were married in Indiana. They moved to Oklahoma to homestead 160 acres."

Dorothy gazes out her picture window and starts describing life on the homestead. I paint an imaginary picture of her carrying out a chore she was expected to perform—taking her mother's prized, bronze turkeys out to graze during the summertime:

The brilliant orange sun rises slowly from the horizon. Dew sparkles on the tall prairie grass like millions of tiny sequins. Scorched tumbleweeds rip across the farm yard and bounce against the fence row. The lanky 12-year-old bounces out of the farmhouse, clutching a rag doll. She jams her free hand into the faded pinafore pocket retrieving corn. She tosses a few kernels in the brick-red dirt. The flock stirs up a cloud of swirling dust. They squawk and run toward her, their wings flapping wildly.

Guiding the noisy flock to the open fields is a tedious process. With every step comes a whorl of fat, green grasshoppers, zinging in every direction. She stops and waits. The birds lunge at the juicy morsels.

Finally, Dorothy leads her charges to the open range and finds a shady spot to sit under a lone elm tree. She eyes the hungry turkeys as they scratch, peck, and nab their food. Suddenly she is startled.

"I was sitting there under the shade tree singing to my doll, just taking life easy, when all of a sudden I looked up and there was a coyote staring me in the face. It wasn't more than three feet away. I yelled as loud as I could. It ran away without bothering me or the turkeys. I imagine that coyote was as scared as I was.

"I don't remember much about my school days. It's all pretty vague. I do recall that my sister, Naomi, and I walked three miles to our one-room schoolhouse in good weather. In the winter, we rode to school on horseback.

"When we were in the seventh grade, our grandmother decided to move to Indiana with an aunt who was a chiropractor. Grandma thought we would receive a better education in Covington, Indiana, than in a country school, so it was decided that we would go back to Indiana with her."

Dorothy can't recall whether or not she wanted to leave friends, family, and familiar surroundings to live in Indiana.

"It didn't matter whether my sister and I wanted to go or not. In those days, it made no difference whatsoever what a kid

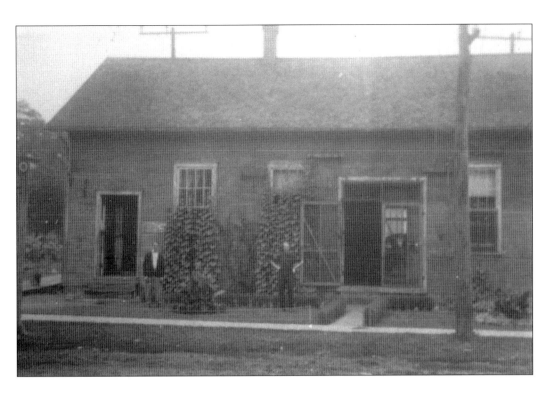

The Michigan Central Railroad Depot in Augusta was built in 1852 and was located on the main line between Detroit and Chicago. It was the first depot to have running water and a toilet. (Courtesy of the Augusta McKay Library's Historical Collection.)

thought. *Without question, you did what your folks wanted."*

When the two sisters arrived in Covington by train, their aunt and grandmother took them home by a circuitous route.

"They were ashamed of us and didn't want the neighbors to see. Both our skin and clothing were black and sooty from the train ride. The engine was powered by coal and with open window all that dirt blew in on the passengers."

Dorothy and her sister spent the entire school year in Indiana living with their aunt and grandmother. It was an unpleasant experience for both girls.

"My grandmother was sure different when we came to live under her roof than she was visiting us in Oklahoma. The first thing Grandma proceeded to teach us was how to use your knife and spoon. She was mean about it.

"She got after us because we walked over the rug too many times. Then Naomi and I went upstairs and stayed there. She wasn't satisfied with that, either. Told us two to get to work.

"That was the worst experience of my life. Grandma never laid a hand on us but, she had me scrubbing the kitchen floor, something I never did at home. I wasn't doing it to her satisfaction, so she said if I didn't it correctly she'd take the mop and wind it around my head.

Apparently, I was walking back over the place I had just scrubbed.

"When things got too bad, Naomi and I would go out to a little spot on the edge of town. We'd sit there a while and talk things over."

She recalls another incident involving her sister while everyone was having lunch around the kitchen table.

The Augusta Depot was purchased from the Penn Central Railroad in 1975 as a Bicentennial project to preserve historical landmarks. It is now used as a museum, which houses local historical memorabilia, c. 2001. (Lee Griffin photo.)

"It was just before the school year was to end. We were all sitting at the table when my grandmother and aunt started criticizing Naomi. My sister always spoke her mind, so she said to them, 'Well, you two seem to think you're perfect.' I wouldn't have dared to talk back. Anyway, they both picked up their water glasses at the same time and threw water in my sister's face. I made up my mind, then, if Mother didn't come and get us at the end of the school term, I was going to run away. I wasn't going to put up with this any more. I had enough.

"Gracious, I don't know why I didn't write my mother a letter and let her know what was going on. Maybe I was afraid to."

Later, Dorothy's parents decided to leave Oklahoma and move to the mining town of Winslow, Indiana. They all moved in temporarily with her uncle's family except Dorothy's father. He stayed behind in

Oklahoma to sell the farm.

"This was altogether a different situation. My Aunt Eddie had eight kids of her own but she took us in and treated us like we were her children.

"Before Dad came to Indiana, we nearly starved. Mother didn't have any money and I guess she didn't get any from Dad, either. My sister and I went out to pick blackberries to sell. They grew wild and were called thimbleberries. There were always people who would buy these big, long berries because they didn't want to get their hands all scratched up gathering them.

"For a time, just about all we had to eat was blackberries and Pet Milk."

Although her father failed to sell the farm, he joined the family in Winslow and landed a job in a nearby coal mine, the largest one around.

"I don't suppose there were safety

Bob Clark, left, and Earl VanZandt, who is wearing his World War I Army uniform, discuss the gas mask and other items he donated to the Augusta Museum, c. 1977. (Lee Griffin photo.)

restrictions because just about every day a mine worker got killed or injured. I know that my uncle (Aunt Eddie's husband), also a mine worker, was badly injured. My two cousins were hurt, also, and one was permanently crippled because of a mine accident.

"After my sister and I graduated from high school, the mines shut down so Dad went to Dearborn and he got a job at the Ford Motor Company."

Dorothy's first job in Dearborn was taking shorthand and typing for a lawyer.

"I got the job because I knew shorthand. My high school commercial teacher recommended me. City hall was located directly across from the lawyer's office, so when they needed extra help, I worked for them, also. Eventually, my boss folded up his law office and the head of the water department in city hall hired me to work for him."

Dorothy continued to take piano lessons as she had on and off as a child. It was at the piano teacher's house that she met her future husband, Bob. He was a boarder. They courted and were married two years later, in 1928. He was employed at a Ford dealership in Detroit, but owned an old, second-hand Nash.

"That old car needed tires and had lots of thing wrong with it, because whenever we went anywhere, we never knew whether we would get back. He decided to get a different car and some guys at work tried to talk him into buying a used one. This was the first time I put my foot down because the used one was going to cost almost as much as a new model. We ended up buying a brand new Model A Ford. It cost $800."

She continued to work at city hall until the spring of 1932 when she became pregnant

with their first child. The Great Depression hit in 1933, the year her daughter was born.

"You see, the stock market collapsed in 1928 and the Depression came along afterward. All the banks closed and no one could draw money out. We happened to be fortunate in that respect. All the money we had saved was deposited in what was called Henry Ford's Bank. We had just enough to pay the doctor bill for her birth.

"People who had funds in other banks lost every cent. Our friends, for example, had money in the American State Bank, which was located on the opposite corner from the Ford Bank. They lost it all and never did receive a penny back. Henry Ford owned his own bank and that's the only reason it didn't collapse along with the others.

"When my daughter was born, all we had in the house was a bushel of apples and a sack of flour. I don't remember what we ate or whether we bought any food, but we must have. Our house was paid for in 1932, so we didn't have to worry about that.

"Things were so bad, I remember we sat by the radio (there was no such thing as television in those days) and listened to President Franklin Roosevelt. He started the WPA, a public works project which gave jobs to anyone who didn't have one. My husband worked for the WPA and made $18 a week. On his salary we managed to pay the utility bills, but little else.

"I really admired Franklin D. Roosevelt because he was sympathetic and did something to alleviate the suffering and hunger of the common people. When Hoover came into office, he was just the opposite. He had soldiers come in and fire at people who came to Washington to

The IOOF building in Augusta as it appeared in 1975. Today, it is vacant but still standing. (Lee Griffin photo.)

Saturday night dances in Augusta, called the "hog rassles," were held at the IOOF building from 1919 until the late 1970s, c. 1975. (Lee Griffin photo.)

protest over the terrible conditions to prod Hoover into doing something about them."

In the middle 1940s Dorothy, her husband and two daughters moved to the Kalamazoo area. By now, she was 45 years old and hadn't worked in 20 years. Nevertheless, she found a position at the Kalamazoo County Building working in the purchasing and maintenance department.

Five years later, her husband, also a County Building employee, died suddenly of a single heart attack.

"When I came home from work, he'd been sitting at the kitchen table because coffee had been spilled all over. I helped him get into bed and called the doctor. At the time I had no idea it was his heart, so moving him was probably the worst thing I could have done. Within minutes, I heard him draw his last breath. Right away he turned stone cold. He was only 60-years old.

"This is the most traumatic experience a person can have, but it's something you can do nothing about. We all have to die, sometime. I didn't receive counseling from a minister or anyone else. I got through the grief by myself. You have to have faith in God. I didn't become embittered like many people do when they lose a spouse or child, and I didn't blame God. It's all part of life. That's the way I look at it."

Shortly after her husband's death at age 50, Dorothy enrolled at Western Michigan University, majoring in biology. Later, she changed her curriculum to teaching.

"I thought that having a college education would give me a job edge that I might have to fall back on it later. It wasn't easy. I had to attend classes on my lunch hour during working hours. My boss didn't like that very much, but I went anyway. I almost got my degree but not quite. I was lacking a

Dorothy Hill poses with her husband, George R. (Bob) following their wedding ceremony in 1928. (Courtesy of the Hill family collection.)

semester in directed teaching and a semester of psychology when I had to quit because of health problems."

She also became involved with the Missionary and World Service Evangelism organization, traveling to countries all over the world assisting missionaries by painting and repairing their properties, assisting in hospital work, sewing needed items and servicing equipment. She took 10 such trips to Ecuador, Africa, India, Israel, and Colombia, among others.

Today, Dorothy believes immorality is the most serious problem facing the nation.

"This is our worst problem, by far. I don't know why all this smut and dirt is permitted to be seen on television. There is nothing uplifting about it. All it does is give kids the wrong ideas.

"Nowadays, it's everyone for himself. It shouldn't be this way. The remedy is a good, old-fashioned revival with the U.S. becoming a Christian country again, where we honor God."

When she occasionally becomes discouraged or disheartened, Dorothy relies heavily on her faith.

"When the blues come on I usually have a good prayer session and then the rest of the day is okay. I never found anything that I couldn't settle with God and myself.

"It's only natural when you get up there in years, you wonder why you are living so long. Gracious, I don't have any relatives left, outside my kids. All my friends are gone, too.

"I would sure hate to live this long and not have faith to fall back on.

Even today, church is a large part of Eleanor Mason's life, c. 1999. (Lee Griffin photo.)

I've known 86-year-old Eleanor for many years. Her daughter, Priscilla, and I were friends from junior high through high school. She was an A student and possessed a beautiful singing voice.

It is late January when I meet with Eleanor in her home, an attractive sandstone and brick ranch, located in a plat on the east edge of Kalamazoo. Melting snow covers the streets and sidewalks.

In the living room Eleanor sits in her favorite green upholstered rocking chair. The back is covered by a hand-crocheted throw. A collection of blue glass bottles, miniature shoes, and boots line the picture window shelf. Glass paperweights, some with flowers and birds inside, cover a coffee table. The fireplace mantle is lined with photographs of Priscilla and her sibling, Byron, a hospital administrator at the National Institute of Health.

She is a short, petite woman with grey hair. She smiles easily and often. During our talk I am touched when she recounts the deaths of her daughter and husband, yet her vigor and excitement for life seems not to have diminished.

"I was born in Doster, Michigan, a small town near Plainwell. I was the fourth girl in the family along with two boys. My mother told me that once Father found out I had been born he said, 'Oh, another girl.' She said the doctor replied, 'Oh, yes, and she'll soon be the pet of them all.

"We never ate oleo margarine, either. My dad said , 'I'm not going to have my family eat oleo with me sitting down there milking cows.' Of course, it is called margarine, now. In the 1950s it was white and there was a little orange packet (all enclosed in a plastic bag) and you had to squeeze and massage the bag until the margarine turned yellow.

"Mother made our own butter. She had one of those barrel churns that went round and round. In wintertime, my family butchered a pig and mother canned the pork and made head cheese. Oh, my, I didn't like the head cheese. It's nothing but fat. You make it by cutting off the head of the pig and putting

seasonings in it. We had a screened-in front porch and Mother always had that smelly head cheese out there.

"The first school I attended was a one-room school called Cressey. This is odd, because in those days before a district could have a school and hire a teacher, there had to be five children. My sister and I (we were only a year and a half apart) went to Cressey School only one year. It was quite a walk, nearly three miles. In bad weather, Mother or Dad would hitch up a horse and take us to school.

"When there were five children to make up a school district we went to the Calkins School which was located a mile north of where we lived. Both boys and girls had to take a six month course in agriculture. It was an agricultural community."

For the ninth grade, Eleanor attended Richland High School, located halfway between Kalamazoo and Hastings.

"My favorite subject was home economics (sewing and cooking). I had to take other subjects, of course. I hated geometry and physics. I just barely passed. You had your choice of chemistry or physics and I took physics. I hated every minute of it. I was very fond of Ernest Webber, the physics teacher. I liked all the home economics teachers. One was a Miss Ivey from Georgia. She had a little twang in her voice.

"Teachers in those days boarded with people in the village. Very few of them lived in the city. Families who boarded teachers gave them their meals. I don't know about their laundry.

"During the Depression days when I was growing up on the farm, we had plenty to eat. The farmers had just what they grew. Very few people went to the store and bought groceries like lettuce and strawberries. Chances are the stores didn't even have them. People bought basic stuff like flour, sugar, coffee, and tea.

"Dad grew our beans, potatoes, and garden vegetables. Some people put cabbages, carrots, and other root vegetables in a barrel and buried it. That kept the vegetables good through most of the winter."

While she was still a high school student,

Eleanor worked summers at McBeth's Resort at Crooked Lake in Delton. She remained working there after she graduated from high school and remained until she married.

"After high school I wasn't trained for anything so I worked at McBeth's as a domestic. They had boarders from Ohio. Apparently there weren't many good fishing lakes in Ohio because lots of them came up here. The boarders stayed at a hotel down by the lake, but Mrs. McBeth fed them in a cottage a short distance from the hotel.

"I worked and lived there every summer. Oh, I liked that job. I'm telling you, I got good wages, $9 a week plus tips. I also helped serve food, did dishes, and cleaned floors every day. Oh, I liked that couple. She was a wonderful cook. I think I gained 10 pounds every summer. Before the Depression got so bad, she'd have 30 to 35 guests and she'd do all the cooking. I suppose I helped a little bit.

"This was before electric refrigerators so she had two ice boxes and on Saturdays I had to cut the butter. I had to cut up a pound of butter into 64 portions. Each person got one of these portions. If we didn't use them all on Sunday, we kept them in the ice box.

"Mr. McBeth had his own ice. Lots of people had their own ice houses in those days. He even sold ice to some of the cottage people by hauling it around in a wheel barrow. The ice was cut out of the lake in the wintertime and kept in an ice house which was well insulated with straw."

Eleanor met her future husband, Kirby, in high school. He lived with his grandparents in Richland.

"I had my first date with him after I graduated. In high school, I dated others, but not him. He was always a lot of fun and had a great sense of humor.

"We were married by the Presbyterian minister at my mother's house. We were both 20 years old. We had a little wedding ceremony with my sisters, their children, and the McBeth resort people as guests. We had cake and ice cream, and we were lucky to have that. I can't even remember if we had coffee. Chances are, we didn't.

Eleanor Mason regularly attends this Presbyterian Church in Richland as she has since she first married in 1934. (Lee Griffin photo.)

"Our first place was the house his grandpa lived in. He died in April of 1933 and that left his grandma on the farm. She couldn't run the farm and since Kirby had been there since he was 12 years old, it seemed a natural progression for Kirby to stay. Well, his grandma moved to Richland to live with her sister and we remained on the farm. This was done in many instances in those times.

"Kirby was quite a dairy farmer. His grandfather was a good dairy farmer, too. We had quite a lot of cows, but I never learned to milk them until much later."

In addition to farming, Eleanor's husband held various other jobs including driving a school bus and working at a local grain elevator. In the wintertime, he worked at the Kalamazoo Vegetable Parchment company.

"The farm fed you, but those other jobs gave us a little extra income. A great many farmers did the same."

Eventually, Eleanor's husband, who was a

The Richland Presbyterian Church (located in the village square), as it appeared in 1976, originated in 1831. (Courtesy of the Richland Community Library's Local History Collection.)

staunch Republican as were several members of his family, was becoming interested in politics.

"Kirby kept looking through the newspaper and would read where the present Kalamazoo County Sheriff, Otto Bruder, did something controversial. Kirby thought it would be fun to turn on the siren and go to an accident. When we would go to Kalamazoo, he would drive by the county building and see all those police cars parked outside and think he would like to be in that position. Eventually, he worked up the nerve and asked for a job. By gosh, he got it."

At first, her husband worked in the jail, answering telephones. The uniform consisted of gray pants, blue shirt, and tie, all of which he had to purchase. He also worked in road patrol and the traffic division where he became chief deputy.

In 1962, Eleanor's husband was appointed Kalamazoo County Sheriff. Eleanor heard the news on the radio. He held the position for 10 years until he lost the election to an opponent.

"It was quite a blow losing the election. It

was hard on Kirby, too. During the time he was sheriff, he'd become director of the National Sheriff's Association, so he had to give up that position. You just live through it, though, like everyone else in politics."

For Eleanor, living in a new house was the most amazing happening she has had to date. When she and her husband decided to leave the farm, they began looking at homes.

"One Sunday afternoon we were just driving around with Kirby's father and his wife. We saw this house for sale at the outskirts of Kalamazoo and we went in. Nothing was inside, but a chair. The builder was sitting in it listening to a ball game.

"The kitchen was painted blue. I'm very fond of blue. We went through the entire house and I thought, oh, what a wonderful house. I thought this is just like a palace. I had no idea we would ever buy this house, but I'll be darned if we didn't.

"Kirby's step-mother, who was Dutch, straight from Holland, said to him, 'Kirby. You gotta have dis house. You be so proud. Dad and I will help you. Dad has da money.'

114

When it came time to put money down, his step-mother thought better of it. She said, 'We better not do dat. Dad and I might need dat money.'

"We ended up borrowing the money from the Federal Land Bank and moved in. Everybody doesn't get to move into a brand-new home. I've been here 38 years."

The death of the couple's 27-year-old daughter was the worst experience Eleanor has endured.

"She got some kind of infection following childbirth. Her death was just awful. It was hard on my husband, too. Oh, he just loved his children. There just can't be anything worse.

"Of course, we took her baby, Erick, and had him for a year. Then the baby's father re-married and the baby went back to them.

"I think it really helped me when I had to take care of that baby because I just didn't have time to feel sorry for myself. I remember I used to go outdoors and just walk around. I felt so bad. It's awful, just awful. You think sometimes you will never laugh again, but you do. Time heals it."

When her grandson grew to adulthood, Eleanor arranged for a small outdoor wedding with 16 guests in her back yard.

"Erik got married the summer Kirby died. He wanted his grandpa to see him get married. We still keep in touch. They all came to visit the day after Christmas. After Erik re-married, he and his wife had a little girl. Now I have two great-grandchildren."

The death of her husband from cancer of the esophagus was another traumatic event in Eleanor's life.

"He had an operation in April or May. Someone asked the doctor how long he had to live and the doctor indicated around Christmas time. I knew it wasn't going to be very long. They put in sort of false esophagus, which is supposed to close when he swallowed food. The thing didn't close.

"He could never lie down flat. We had to have a hospital bed for him so I moved all the furniture out of the living room and cared for him there. Visiting nurses also

Twenty-year-olds Eleanor and Kirby Mason on their wedding day, c. 1934. (Courtesy of the Mason family collection.)

came twice a week.

"I could have had Hospice but I refused it. I remember the reason why. I didn't want to admit to myself that he was dying. Hospice is for terminal patients and I thought if I took care of him, I wouldn't have to admit it. I knew he was going to die. I think I cried more before he died than afterward. I don't know why, but I remember sitting there crying and then going to bed crying. What else can you do?"

Eleanor joined the Presbyterian Church in Richland the year she was married. When the children were youngsters she taught Sunday School for 10 years. She remains active.

"I'm a Presbyterian through and through. The church is a big part of my life. If I didn't have my church, what would I do with myself? I love my church. I give and work for it real hard. We women used to have bake sales or anything else we could think of to earn money in order to fix up that old church. It's beautiful now."

Future plans for Eleanor include remaining in her own home and keeping out

This is a view of downtown Kalamazoo at Burdick and Main Street in the early 1900s. (Courtesy of the Rick Shields Historical Collection.)

of a nursing facility.

"Oh, I don't want to go into one of those places. I told my son never put me in a nursing home. I'll hire someone to take care of me.

"I've talked to some people about this and they said if I had someone come to the house I'd probably be forever criticizing what they do. Without a doubt, I will. I'm even conservative with water. I don't stand under the shower for half an hour. For a tub bath, I only fill it half-full of water. I was brought up that way. We didn't waste things.

"I have a 94-year-old sister in a nursing home. There are times when a family can't take care of their older people. In that case, nursing homes are available.

"Another thing. I don't want to be cremated. It's not for me. I told my son if he has me cremated, I will rise up and haunt him. I've got my spot in the cemetery and that's where I want to be—right beside Priscilla and Kirby."

Despite having a bout with breast cancer more than 10 years ago, Eleanor considers her health good. She participates in many church community functions.

"I still drive a 1986 car, but it is getting old, too. I drive to the grocery store and to church in Richland which is nearly four miles away. I don't drive at night anymore. I figure at my age, I shouldn't.

"Besides the many women's activities at the church which I participate in, I play cards with a group of ladies. Also, when Richland has their big Fourth of July celebration, the church has a pie tent and I always bake two rhubarb pies for that."

In addition, Eleanor cans several quarts of tomatoes in the summertime, down from the bushels she used to put up, and she recently accepted an officer's position with the Order of the Eastern Star. Too, she remains strong in her faith.

"I do believe in an afterlife. I'll probably see Priscilla and Kirby in the next life, but not as I knew them here on earth. It will be different. I always think I will hear Priscilla sing. She'll be singing with some of those angels up there."

JESSE MCARTHUR

Jesse McArthur continues to enjoy eating pig hocks and cabbage, c. 1998. (Lee Griffin photo.)

My introduction to 103-year-old Jesse is through her Methodist pastor who makes frequent visits to Jesse's home, located at the edge of Hickory Corners. This little village which is located in Barry Township, northeast of Kalamazoo, was named for large hickory tree.

According to the story, when early surveyors attempted to stake out the center of the section in the area, they found a large Hickory tree at the exact location the stake should have been driven. It is reported the surveyor said, "We won't have to mark this one, boys, we have a perfect Hickory corner." For years the tree grew at the intersection of Hickory and the Kellogg School roads, directly in the center of the village.

On this occasion when Jesse's pastor makes her visit, I tag along. My expectation is to get acquainted with Jesse, hoping she will invite me back to interview her.

Jesse and her pastor exchange pleasantries and banter, which reveals the centenarian's quick wit and humor.

Later, on a warm, humid June day, I return to Jesse's home for an interview. I also bring our lunch—ham-salad sandwiches and cheese-broccoli soup.

Jesse covers the table with a white lace tablecloth and places white candles in silver candlesticks in the center. We chat during the meal then retire to the living room for the interview.

She then pulls a large photograph from an end table drawer.

"That's me riding in the Hickory Corners Memorial Day parade a couple of years ago when I was selected to be the Grand Marshall. The Gilmore Car Museum furnished an old car and had it all fixed up for the parade."

Jesse is the youngest of two sisters and two brothers. She is the only sibling still living.

As a youngster she lived on a farm near Dowling. Her father, in addition to milking

Jesse McArthur's home, now owned by Michigan State University, is located near the MSU Dairy Center, shown here. (Lee Griffin photo.)

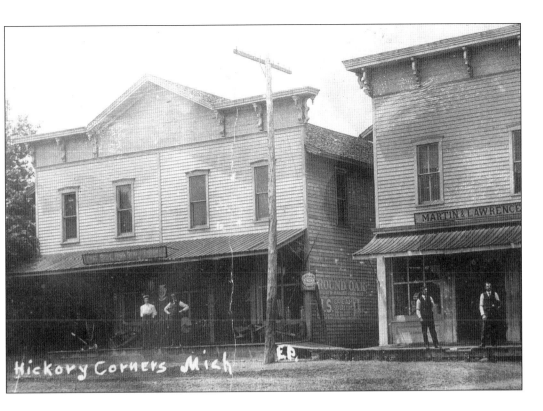

Hickory Corners in the late 1800s. (Courtesy of the Rick Shields Historical Collection.)

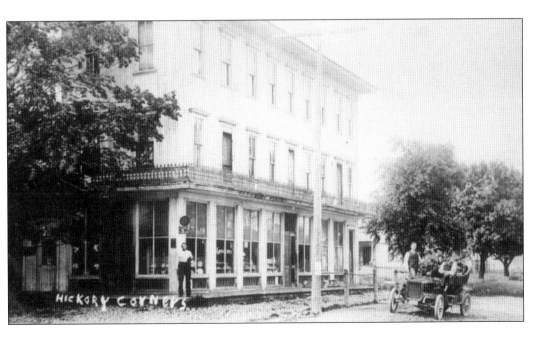

An early photo of a grocery store in Hickory Corners. Note the automobile on the right. A portion of the building still exists today.

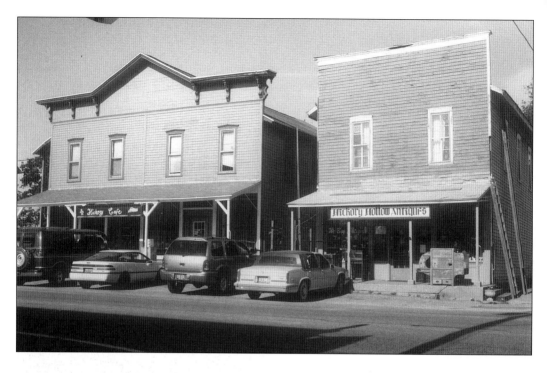

In 100 years, Hickory Corners has changed little, c. 2001. (Lee Griffin photo.)

cows and caring for pigs, chickens, and horses, operated a threshing machine. He often traveled to area farms where he did custom threshing (the process of separating various grains, such as wheat or barley from its stalks).

Jesse left the farm to attend high school in Hastings, working for her room and board by caring for two small boys.

"After I graduated from high school, I didn't want to go back to the farm. In the city I had a good time and I knew everybody, boys and girls."

In Hastings, Jesse worked in an office and later met her husband, Lyle. Subsequently, they married and had two children, a son and a daughter.

"The happiest time in my life was when I met my husband. I was almost 19 years old. The first time I went out with him if he had asked me to marry him we would have gone down and got married. When he took me in his arms I was so thrilled I just knew I had to have him for my husband. He was tall (six

feet) and beautiful, with brown eyes. I knew his sister. She and I had been chums for a long time. She got me to meet him."

After living several years in Hastings, the family moved to Grand Rapids and then back to the area in 1941. They built their house in Hickory Corners where Jesse continues to live 70 years later.

"I was 36 years old when we moved here. Think how long that's been. At first, I thought Hickory Corners was the worst place I ever saw. After I got to know everybody, I began to like living here.

"My husband had an auto repair garage in Hickory Corners for 11 years. When he was working under a car, I'd be working too, waiting on the trade. I got so I hated it. The farmers around here would do their chores and then come up to the station with something that had to be done on their cars or tractors or other kinds of equipment that didn't work and had to be fixed right away. I got sick of farmers. During the war they worked in factories and made more money

than they did on their farms.

"I also worked during war, at Eaton Manufacturing. I polished valves for airplanes. Boy, we sure worked. My sister, who was older than I, also worked at Eaton's. As quick as the war was over I was out of there."

Thirty years ago, shortly after Jesse's husband died, Michigan State University wanted to purchase her home which is located adjacent to university-owned land currently being used for dairy and farm research.

"I named my own price and the college people agreed. I have a lifetime lease which makes my life much easier. Every once in a while the boys from dairy farm come around to fix anything that needs work or to make repairs on the house.

"It tickles me because one of the farm boys brought a young women from the university up to see me. He said he had to check the furnace. I told him I was having a nap. He said okay but brought her with him anyway. She is going to write a little story in their paper about people who live in university houses. If there are others living on university land I don't know about them. Anyway, she kept asking me questions, and then I told her I didn't want to talk anymore. She thanked me and said that was okay. It does get tiresome, having so many people come and talk to me, asking questions. This girl from the university was nice and I sounded like a little kid, but I didn't think about it until afterward. At my age, I can get away with it.

"Oh, I had a busy life, a good life. I have no complaints. I was always busy. I worked hard at the church, at school where I was P.T.A. president and at the local chapter of the Order of the Eastern Star. I took the office of worthy matron in Star and I went to everything there. OES put on a 100th birthday party for me. Everybody around the area came. The Eastern Star girls often stop here to visit. Oh, I had a busy life and I enjoyed it.

"After I broke my leg I had a girl stay with me, and that's when it got so I hated to have

Fourty-five-year-old Jesse McArthur was always busy with church, school and lodge activities. (Courtesy of the McArthur family collection.)

anyone living with me. You have to talk to them. At night she would make a pot of coffee and set it on the table where she would drink her coffee and smoke her cigarettes. I worried about her. Sometimes she would do down to the basement or go into her room to smoke. I could smell it. I thought then I would rather be alone.

"I don't know why I'm living so long, but it helped that I didn't drink or smoke. Mother was 81 she died, my sister was almost 90, and my two brothers were around 70 when they died so maybe genes have something to do with it.

"My health is good and I eat good. Nothing bothers me. I eat pig hocks and I

love them. I love them with cabbage or sauerkraut. I usually put bacon with sauerkraut. I love pickled pigs feet, too. At my age I can eat anything.

"Sometimes it's hell to be 103 and lonely. All my old friends are gone, but I have quite a lot of young friends, and my daughter and her husband are close by. It's been lonely, though, since my son, Paul, died, because he came out to visit every week. He'd always come to the back door.

"Even now I can just see that smile of his when he'd see me coming to the door. Oh, I miss him so. He and his wife didn't have any children. I wish they had."

Her son, she explains, paid her a visit one day and revealed he had a tumor in his lung. He later died of cancer.

At age 103, Jesse maintains that most folks treat her "beautifully, which is a big surprise."

"Well, no, it's not a surprise because I always treat everyone else that way, too.

"My greatest fear is my daughter might die before I do. She is over age 70 and many people die at that age. She has me to think about, but I don't have much worry.

"If I get to the point where I can't take care of myself, I'll try and find someone to live with me. I will hire someone, but you know, you can't find them, hardly. They are expensive, but what's the difference? I might as well spend it as to leave it all to my daughter.

"I refuse to go to an old people's home. I want what I want—and when I want it. Well, I won't have long to think about it, anyway. I'll be 104 in August."

"Sometimes, I wonder why he Lord is leaving me here so long. I asked my little lady minister, and she says I am here for a purpose. She says I am a connection between here and there, but all my family is up there. I hope they are in heaven. I guess they would be.

"I am ready to go anytime, but I hate to leave my home. I love my home. I'm not afraid to die, but I don't want to lay here very long. I won't, because Barb, my daughter, calls me every morning and if I don't answer, she will be right over here.

"When I go to bed, I ask my son and husband to help Jesus watch over me. I feel like they might, you know, so I just pull up the covers, say my little prayer, and go to sleep."

Main Street in Hickory Corners during the early 1900s featured plenty of mud and ruts. (Courtesy of the Rick Shields Historical collection.)

Ed Overton spent his youth working with his family on a southern plantation, c. 1999. (Lee Griffin photo.)

Ed, who describes himself as self-raised and self-educated, is an 86-year-old black man who lives in a small, white bungalow on the north side of Kalamazoo, Michigan. Although a few poor white folks live in the neighborhood, this part of town is known as the "black section." Many white people avoid driving through the area, citing drugs, crime, and general feelings of unease

A mutual friend suggests I talk to Ed. When I tell a co-worker my plan to do so, she recommends I take along Willy, my large German Shepherd dog. I ignore the advice.

Later, at his home, Ed ushers me into the tidy living room. I sit opposite him. He sits on a couch covered by a faded Indian blanket. At one end of the room a soap opera is blaring on the television set. He lowers the volume.

Ed, who is good looking, appears 20 years younger. He wears a fresh white shirt and is cleanly shaven. We chat a bit and I tell him the Willy story. He laughs and says he's not surprised. He compliments me for having "a good heart."

Throughout the interview, I am struck by Ed's deep religious convictions and his absence of anger or bitterness after having lived with discrimination for more than eight decades.

"I was born in Forrest City, Arkansas. There was seven boys and three girls. I was the oldest one. My dad died when I was nine years old. I had to be like the man in the family.

We lived on a plantation and worked for white people. They called us share croppers. When you lived on the plantations, the

Located near the entrance of the Kalamazoo Institute of Art, this Kirk Newman sculpture, entitled People, *is an elegant statement emphasizing the city's commitment to the arts, c. 2001. (Lee Griffin photo.)*

Gathering for this family portrait are, from left, Ramona Lumpkins (step-daughter); son, Michael Overton; daughter, Ethel Hughes; Ed; David Seaberry (step-son); and son Junior Overton. (Courtesy of the Overton family collection.)

white man tell you when to go to the field, when to come home, and when to do everything. You don't have a life of your own. You do what they tell you.

"The man, he tell ya you get half of what you make. You do the work and they get half of it. When it gets time to sell the cotton, you get half of what it brings. When the white man get through charging you for food and things, you got nothing but food. It was a good deal for him. He was making all the money. We were making nothing. You couldn't accumulate nothing at the end of the year. I look back on it now and it was awful. When you're into that, though, you don't pay much attention."

An incident, recreated here, stands out in Ed's memory:

The red fertile soil contrasts with the green shoots of the young, tender cotton plants. Old, one-room shacks surround the dilapidated big house, dwelling of the head tenant. The Overton family cabin is like the 50 others on this 1000-acre plantation. Built of rough, old boards, the structure features a tin rood, single door, and a window with no glass. Inside is a blackened fireplace, a few wooden chairs, a table and a wooden chest. Burlap feed sacks and battered blankets at one end of the room serve as sleeping quarters. Outside, an old hand water pump is shared with neighbors.

Eight-year-old Ed gets up at daylight, finishes his breakfast of sorghum-drenched pancakes, and heads for the fields with his brothers and sisters. They will toil until darkness. By mid-morning the heat is stifling. Today, Ed's job is plowing a field of corn with Henry, a brown mule. The work is hot and monotonous. Sweat streams down Ed's

Dressed in his Sunday best, Ed Overton, enjoys attending church, c. 1996. (Courtesy of the Overton family collection.)

dusty face. After several hours in the field, Ed suddenly stops in his tracks. Another mule, working nearby, splits the air with a single, half-bray, half-brawl. Abruptly, it drops with a thud. It twitches. The mule is dead.

The plantation owner comes running. "Boy, he yells nervously to Ed, "You get Henry in the barn and you don't work him until the sun does down and it cools off, you hear?"

"I told my Dad about Henry and said Boss (plantation owner) was worried about his mules, but he wasn't worried about me. He didn't say a thing about me getting out of the sun.

My dad asked the boss about this later, and you know what Boss said? 'Ed ought to have sense enough without being told.'"

On the plantation Ed attended a one-room school.

"You would go for two or three months, winter months. You got all the crops to take care of at other times. When that's over, then you go to school. The boss had it all figured out. He knows you can't learn much in just a couple of months."

On one occasion, Ed recalls, he didn't have a school book and no money to buy one so he approached the land owner and pleaded with him to buy a copy .

"Boss says to me, 'Ed, you don't need no education to plow with Henry.' I felt so bad. 'Don't need to read,' he said. Why, I think about that now, a lot of times.

"I learned everything after I come out of school. I'm self-educated. I learned from different things and different peoples. Being around these things, I learn more than people in college. Why, I lived through all these things kids is studying about. Races, you know. So what is there for me to learn? Nobody can tell me about blacks, whites, Mexicans, or anybody else. I been around all those kinds and dealt with all of them. I know my way around pretty good.

"On the weekends for fun, we played ball and card games, sang songs, and danced. There was one car on the farm and the boss, he take it to town on Saturdays. You could ride along to town with him or go by mule.

"There was a church on the farm and on Sundays black families would have services there and sing spirituals. The plantation owner would come to that church with his family and sit outside, listening to the music. No, he wouldn't go inside, but he'd brag about the good music. He was proud of his people."

In 1943, Ed left the plantation and came North. He was 40 years old and had a family. His mother and several brothers had left earlier and settled in Southwest Michigan.

"When the war broke out, that's when many blacks left the plantations because they could get jobs in factories and make lots more money. When I told Boss I was going to leave he says, 'Well, Ed, I hate to see

you leave, but if you ever want to come back, you let me know and I'll send for ya.'

"Boss asks what I'm going North for, and I say, 'Well, they tell me you can make a dollar an hour.' You see, Boss is paying us $2 a day. Anyway, he tells me, 'Go ahead. That's good money.' He then says to me, 'I know you'll make it, Ed. You're all right.'"

Nevertheless, Ed notes, when he was growing up, many share-croppers on surrounding plantations were afraid to leave the land.

"They was afraid because the white mens would say, 'You go north, you freeze to death.'

Those that did leave had to slip away, because the owner's thinking was, that's my nigger. He'd get the dogs and bring you back. Then whip you. He was cruel that way. You knew what to do and what not to do. You was his.

"My boss, he was a pretty fair white man. There was some good white people down there. The last time I went back for a visit, he ax me how I been and I said, 'Real good.' He's dead now. It made me feel good that I didn't have to go back. It was just like going out of prison."

When Ed came to the Kalamazoo area and started job hunting, he was told there were no jobs for blacks.

"They came right out and told me that. They didn't say 'black,' they said, 'you people.' 'We don't have any jobs for you people.' They had one or two blacks working for them but those folks were mostly born and raised up here, you know."

Eventually, Ed landed a job at a paper mill, one industry which was hiring blacks. Later, during wartime, he found employment at a foundry. He worked there for 13 years until the business folded. He then secured a position in the maintenance department of a Kalamazoo hospital and worked there for 24 years until he retired.

Although Ed also experienced discrimination in the North as he had in the South, he states there were subtle differences.

"Up here you could sit next to a white person at a soda fountain, but you could tell he didn't like it or was uncomfortable. In the South, they had a sign on the door that says 'blacks here,' 'white's only' there. Blacks could only go to certain places. You couldn't even sit down with whites. That was the difference between North and South.

"It's a terrible feeling, you know, but people don't realize it until they come in contact with this type of thing. People can talk and tell you about these things happening, but you just can't believe folks will treat you like this. It's a lot better now. It gets better all the time. People are coming together more."

At present, Ed belongs to the Mt. Zion Baptist Church in Kalamazoo but is not very active.

"I used to be. I kind of backed up a little bit. I didn't really know about the church until I studied the Bible—who God was and where the church was. Everybody think the church is where the building is. That isn't the church. It's right here in your heart. That's what I found out.

"I always went to church. My mother made us kids got to church and Sunday School. I was a deacon here but it go so there were so many hypocrites.

"When something happens to you, and you need these folks who say they're Christians, they turn away. You don't have to ax nobody whether you are among Christians. The same way with your friends. You don't have to ax who your friend is when you need one. You know who helped. You know your enemies because they walk away from you. That's what I learned about life. You can be religious and not a Christian person."

Ed concedes he still enjoys attending church, but says he finds many behaviors and actions he doesn't approve of. Nevertheless, he still goes to services.

"I go because Christ say, 'Go among them and let your light shine.' Somebody see you going to church and maybe they go and get

Business appears slow for this Kalamazoo shopkeeper in the early 1900s. (Courtesy of the Rick Shields Historical Collection.)

something out of it. That's what I go for. Not to be saved because nobody can save me but God. I could go down there and shout but you can't shout your way to heaven. You can't buy your way, either."

It is his conviction that folks who don't believe in God are "Satan's people," and warns that Satan is always trying to win Christians over to his side. If individuals aren't strong, he warns, "Satan will get them."

"You just have to be strong with God and have love in your heart. Satan won't get me. I love everybody and treat them right.

"They say Abraham Lincoln freed the slaves. No, he didn't. God did. A lot of people don't think about this. They call me crazy if I say it, but I don't care what people say. I know how God got rid of slaves from the white people. You see, God gave the knowledge for inventions: a big tractor, truck, and all those big machineries; and now the white man don't need you down there on his farm. God gave man knowledge to make all these things and that freed me."

Ed acknowledges that he doesn't look his age and notes he has never been sick or ever hospitalized. He willingly reveals the reason for his long, healthy life.

"My secret is the good Master, the Lord. I serve God, treat people right and try to live right to the best of my knowledge. I eat mostly vegetables and just a little meat. Less that I used to. I try to stay away from junk food. I do pretty good at it, too."